Dream Weddings
Create Fresh and Stylish Photography

Neal Urban

AMHERST MEDIA, INC. ■ BUFFALO, NY

About the Author

Neal Urban is a wedding photographer from Buffalo, NY, whose work for discerning clients takes him to exotic locations coast to coast. Neal has earned numerous Accolades of Excellence Awards in WPPI's annual print competition (Wedding & Portrait Photographers International). In 2011, he was the winner of *Photo District News'* Top Knots People's Choice Award. Neal was also recently a featured photographer in the Chinese edition of *Cosmopolitan Brides* as well as in *Rangefinder* magazine, which called him "one of the most sought after wedding photographers in the industry."

Copyright © 2014 by Neal Urban.
All rights reserved.
All photographs by the author unless otherwise noted.

Published by:
Amherst Media, Inc.
P.O. Box 586
Buffalo, N.Y. 14226
Fax: 716-874-4508
www.AmherstMedia.com

Publisher: Craig Alesse
Senior Editor/Production Manager: Michelle Perkins
Associate Editor: Barbara A. Lynch-Johnt
Associate Publisher: Kate Neaverth
Editorial Assistance from: Sally Jarzab, John S. Loder
Business Manager: Adam Richards
Warehouse and Fulfillment Manager: Roger Singo

ISBN-13: 978-1-60895-699-9
Library of Congress Control Number: 2013952524
10 9 8 7 6 5 4 3 2 1

Check out Amherst Media's blogs at: http://portrait-photographer.blogspot.com/
http://weddingphotographer-amherstmedia.blogspot.com/

Contents

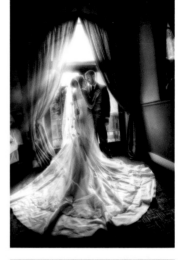

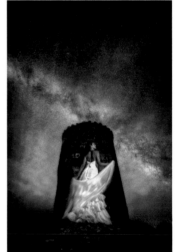

1. Engagement Session (with Pets)

I encourage couples to start their wedding coverage with an engagement session. Not only can they do great things with the images (save-the-date cards, invitations, signing boards, etc.), but it also gives them some experience in front of the camera. For most clients, it's their first time shooting with a professional photographer, so they'll likely be a bit nervous. Heck, I would be, too.

"By the time we send the dog away, the clients are in picture-taking mode."

The engagement session also gives them an idea of what to expect on their wedding day. They get a sense of the direction I give, the poses, my personality, and how I sometimes work quickly for photojournalistic images and then slow things down to get the lighting and posing perfect. When we arrive on their wedding day we've already created a bond and can get right to work.

A lot of couples want their dog included in their photos, so we start the session with those shots. We generally let the dog do its thing and follow along. This keeps the attention more on the dog and allows the couple to relax a little bit as we get the camera clicking. It gets the chemistry going between myself and the clients. By the time we send the dog away, the clients are relaxed and in picture-taking mode.

The Dog Whisperer

April and John (below) had made some fancy renovations to their home, so they decided to do their engagement shoot there—in the place where, after a hard day's work, they come to enjoy each other's company, cook, and spend time with their dog.

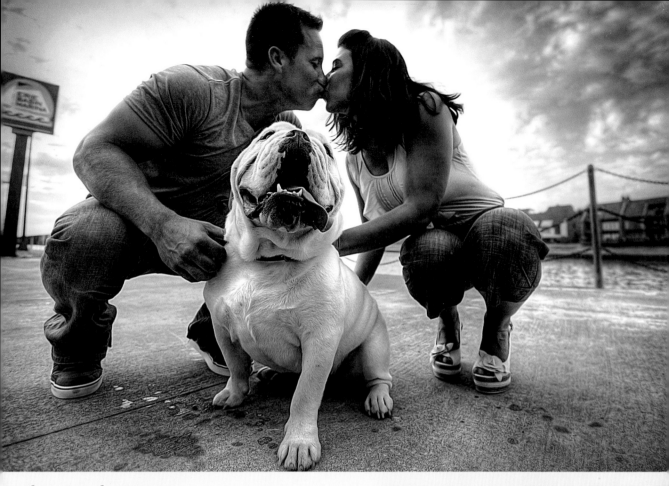

Their Level or Yours

With animals or kids, it often helps to get down on their level, coming face to face with them. Hurley the bulldog (above) was a blast to work with on this hot summer day. His mouth was wide open, but you could tell he was smiling. I shot this with a Nikon 14–24mm lens at 14mm and f/4.

Conversely, how about bringing them up to your level? When you leave your house, the dogs in the backyard hop up on the fence and look at you with those big puppy-dog eyes, wanting you to return. That's the look I was going for in the image to the right. To include the rustic fence, we propped the dog up and the couple got close for a small family shot.

I consider myself a bit of a dog whisperer. However, this dog wasn't having my whispering ways. He was fine until I lifted the camera, but as soon as it covered my face, the growls began. I posed April and John on a chair and asked them to get comfortable. The dog was sitting on the other chair and mostly kept his eyes locked in on me. When I asked April and John to kiss, however, the dog shot them a glance. It was perfect.

2. Let It Snow

If you live anywhere above the equator, most likely you're going to see snow at some point. We live in Buffalo, NY, so we have no problem getting our fair share of it. Fortunately, just because it snows that doesn't mean shooting has to stop. We actually look forward to photographing in it. Many couples love winter and winter activities—and the monochromatic look of winter landscapes is very well suited to portraiture.

Playful and Romantic

When shooting in a winter scene, you can encourage them to get playful and silly by suggesting a little snow fight. Then, they can warm

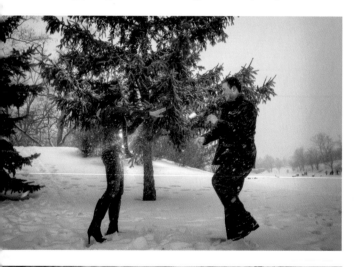

each other up by getting close and romantic. The posing options are limitless.

Take Time to Warm Up

No matter where you end up shooting, you should try to keep the cars nearby so the couple

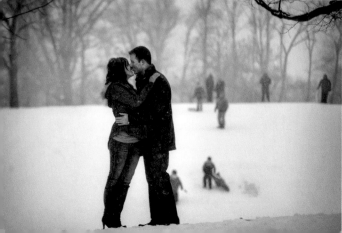

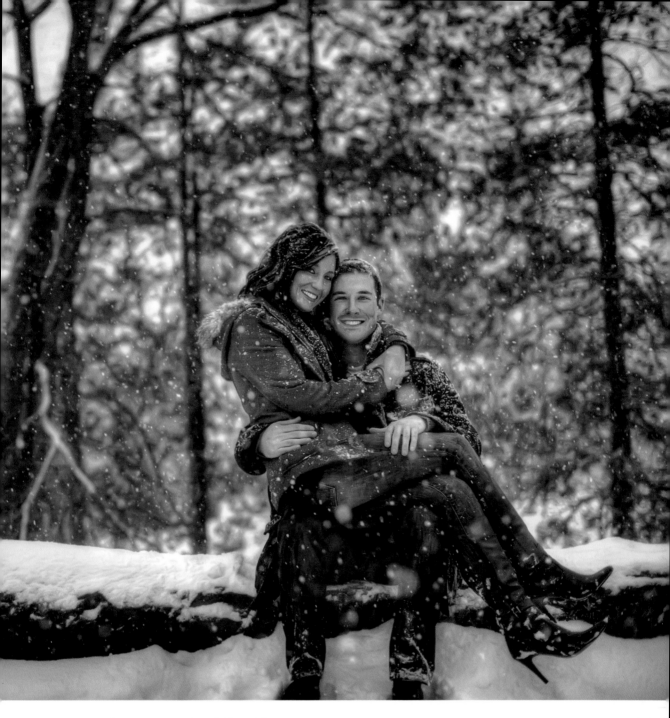

can warm up from time to time. When it's cold out, people's cheeks and noses will get very red. Their eyes and noses will also start to water if it's very cold. Allowing the couple (and yourself) some time for breaks will make the shoot more comfortable.

Cold Gear

You want to warm yourself up, but your lenses will fog up if you shift them from the cold outside to the warm car. I usually put my camera gear in the trunk, so it's safe but not exposed to those temperature changes.

3. Night Photography

Take Your Time

One nice thing about engagement shoots is that you have control of the time and place you'd like to shoot. When shooting a wedding, you are totally locked in to the time the clients want you to shoot—which is most often the worst time of the day (in terms of the available lighting). With engagement shoots, you can mix it up and shoot at night or whenever you like.

Location Selection

For best results, plan your night shoot in a place where there is a lot of ambient light to make the background look interesting. The images here were created on the streets of New York City, so we had plenty of store fronts, tall buildings, neon lights, and lamp posts to include in the scene behind the couple.

Add Some Light

One approach to shooting at night is to add light on the subjects to balance them in relation to the ambient light in the background. Flash works well for this purpose, allowing you to freeze the subjects with the short burst of light. Then, leaving the shutter open past the flash sync speed allows the ambient light to continue to register to whatever level you choose.

BELOW—Danielle (my wife and assistant) was to camera left holding a flash fitted with a diffuser cap. I posed the couple close to a street lamp, producing the highlights on the back of the bride-to-be's hair.

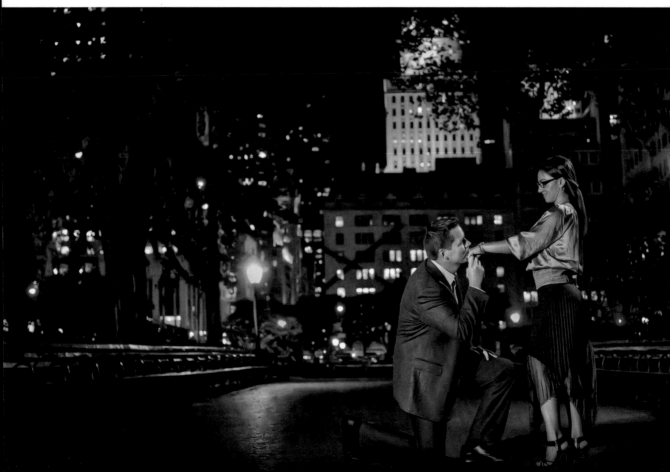

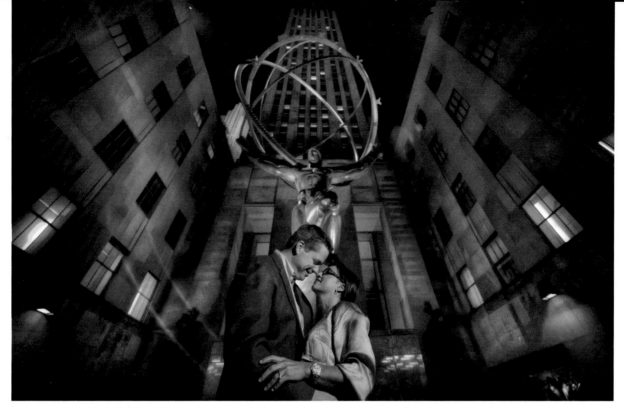

ABOVE—Danielle held the flash right over the top of the camera; I was shooting with a 14mm lens, so this kept her hand out of the frame.

Use Ambient Light Only

Another approach is to shoot using only the ambient light. Identifying light sources and positioning your subjects relative to them can create beautiful results—as seen in the images to the right.

TOP RIGHT—This image was created using ambient light only; the subjects were positioned in the beam of the street lamp to make them stand out in the composition. I used Photomatix to bring out the light at the end of the tunnel and the red area at the top of the arch, as well as to tone down the lamp itself. I didn't want an intense HDR look, just some subtle tonal enhancement to reveal the details in the scene.

BOTTOM RIGHT—We created our first image of the night in front of a store window with a street light illuminating the couple. They had been a little nervous about the session, so I showed them this image right away—and it was smooth sailing from there!

4. Being Playful

Encourage Interaction

The best way to get clients to interact with each other is to encourage them to be playful.

Before the shoot, I always advise the couple to be physical with each other during the session—and, no, that doesn't mean beating each other up. What I want is to see a lot of contact between them. I want them to act as if they can't keep their hands off each other. I want them to grab each other and throw each other around, if the spirit moves them.

Asking them to try to make each other laugh is another way to elicit poses and expressions that look and feel authentic to them as a couple.

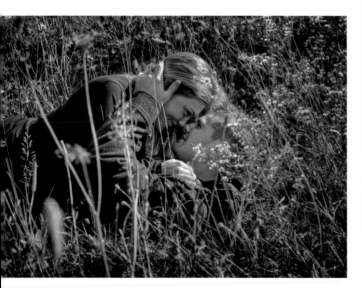

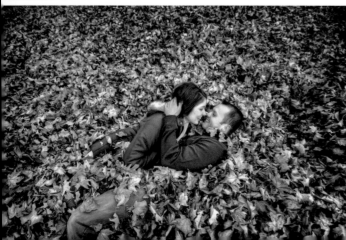

Laughing, smiling, giggling, and playing will take their mind off the camera and get them focused on each other.

Saying things like, "Grab him/her by the bum and pull him/her in for a kiss!" always gets a good reaction, too.

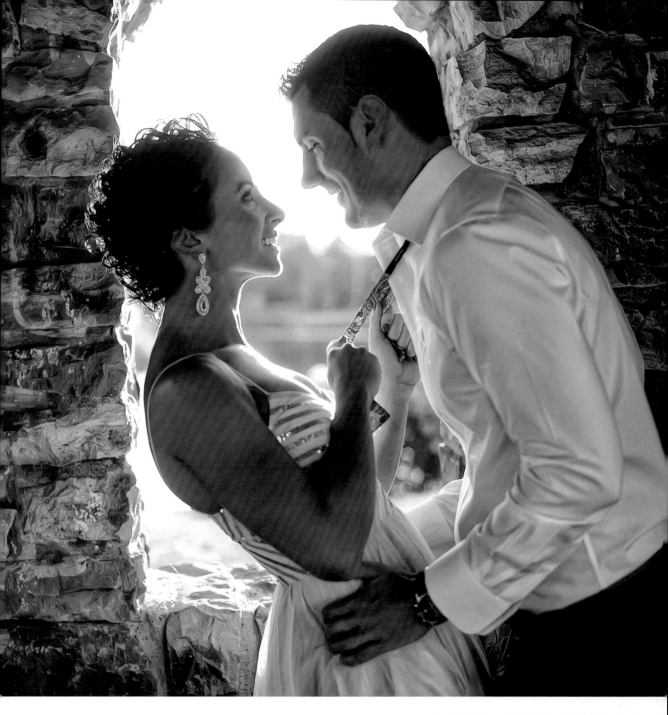

Be True to Who They Are

Engagement portraits are best when they are true to who the couple really is. This couple likes to stay home and cook, so we did their shoot in their newly remodeled kitchen. I planned to have her looking at the camera, but she didn't think we were shooting and grabbed a sip of wine—and it looked perfect. The pose captured their personalities; he's a serious kind of guy, while she's a bit more free-spirited.

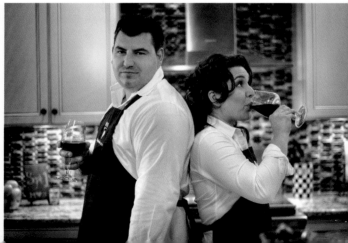

5. Getting Ready

All the Ladies

Usually, when the bride gets ready she is surrounded by her bridesmaids. This is always a fun part of the day, as you document the happy girls helping with the dress and their reactions to seeing the bride in her beautiful gown.

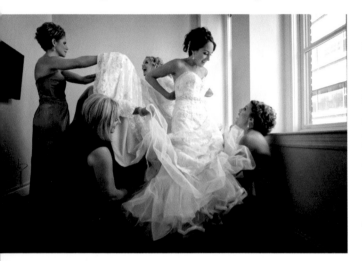

The Bride Alone

Once I get all of the action/photojournalism shots, I send everyone out of the room so that

"This is the moment when I take control, showing the bride that we're in this together now."

it's just us and the bride. The bride doesn't need an audience when it comes time to pose for her pre-wedding portraits—and a few moments of calm and quiet can help us all to concentrate.

At this point, the bride is usually overwhelmed with excitement and feeling very confident, so it's time to capture some images that

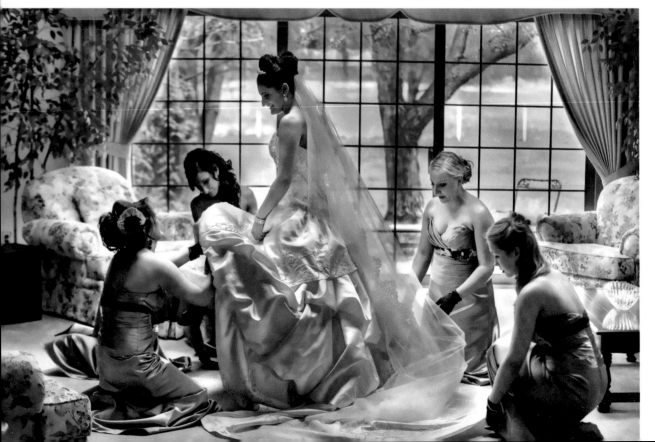

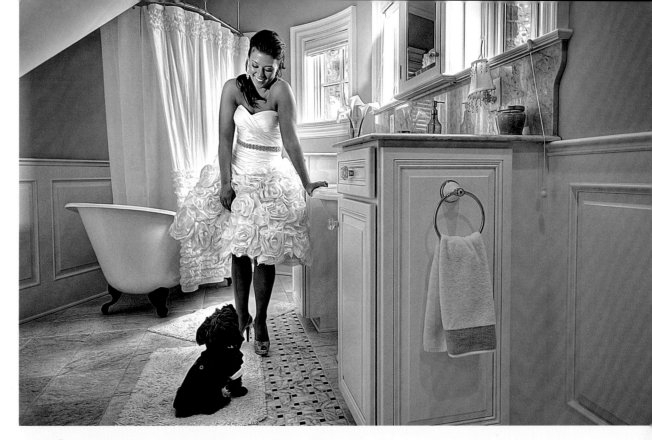

With Her Dog

People love their pets and they want them to be a big part of the day. I love it when couples dress their dogs up for the event. However, animals are very unpredictable; you never know what you're going to catch them doing. This dog was small and fast—almost impossible to get a shot of. We were doing portraits in this beautiful bathroom at the bride's parents' house when the dog suddenly entered the room, sat in front of the bride, and looked up at her. Perfect! (And then it ran off as quickly as it entered the room.) This was one of the few shots I got of the dog, but it only takes one! When working with animals, always be ready for them. Don't even try to force the animals to do anything that they don't want to do; it will almost never work. Just be patient and wait for the right moment to happen. When it does, be quiet and still—and take the shot!

show her beauty. With the emotions running high but the room now quiet, I can usually get a shot that is very natural and beautiful, like the one to the right.

This is the moment in time when I am no longer just a photographer working with a client. This is the moment when I start to take control of the day, showing the bride that we're in this together now. A special bond forms in those moments, and that connection sets the stage for the rest of the day.

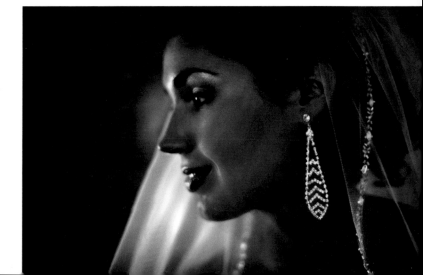

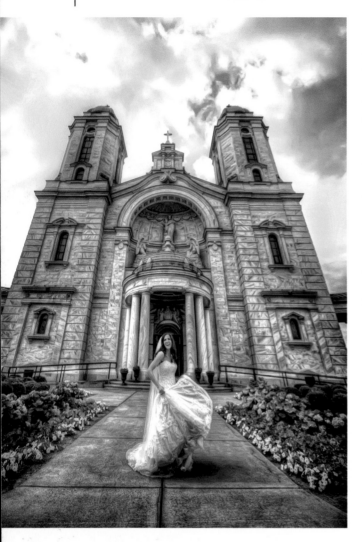

No Tricks

Sometimes the best images are the simple ones. No camera tricks, no special lights, no traveling to amazing locations. A beautiful bride with available light is all you need.

Add Some Movement

When the bride has a larger dress with some nice detail in the train, a simple way to show it off is to have her walk or run. Her motion will give the dress a chance to flow and not look so straight up and down. This also gives the bride a chance to interact with her surroundings, which leads to a more natural look. When you have strong architecture, some subject movement also helps create contrast between the hard lines of the background and softer lines of the subject. This makes your subject stand out.

Lighting and Separation

The bride had just finished dressing and her hair and makeup were done. She sat on the bed and faced the window. I stood to the left of the window. The makeup artist, still working on the bridesmaids' makeup, had a tungsten light that lit up some of the background. I used this light for backlighting to separate the bride from the dark background. This bride had very dark hair, so that little bit of backlight played an important role. I also like the warm glow of the tungsten light against the cooler light from the window. I love how the cool colors gave her very dark hair tints of blue. The window also added some nice reflections in the bride's dark brown eyes, making them sparkle.

7. Combatting Nerves

Arrive Early and Take Your Time

Arrive early, happy and confident, at the location where the bride is getting ready. Get your camera out, find the bride, then offer her your congratulations and compliment her on how beautiful she looks. Make some small talk to ease her nerves. I like to ask if she got any sleep the night before. This takes her mind off the stress of the day—and distracts her from the camera in your hand.

Start with Details, Show Samples

After the small talk, I ask where to find the dress, shoes, etc. This gives the bride a chance to take us on a tour of the house/room. Along the way, I take some snapshots—just to get the camera clicking and put myself into work mode.

When we get to the dress, I compliment it and take a few shots right away, with the bride

Work around the bride from different angles to find the most flattering perspective.

standing there. I look for mirrors and reflections that will let me get the dress *and* the bride in the shot. I ask the bride to hold the shoes or parts of the dress so that she is getting photographed. This shows her that she doesn't have to "perform" to get beautiful shots.

> "Arrive early, happy and confident, at the location where the bride is getting ready."

Once you have something amazing, show it to the bride to boost her confidence. (Don't do this all the time, though; one to three times during the wedding day should be plenty.)

In Her Dress

Once she's in her dress, the bride should be excited, confident in your skills, and comfortable with you as a person. Most hotel rooms have unflattering lighting, so turn it all off and take her near a window where that beautiful light is coming through. Pose her body toward the window and turn her face back toward you. A beautiful, confident smile will come through the lens every time!

Make a Personal Connection

Don't just show up and put a camera in the bride's face. How impersonal is that? It would stress me out, too! Once people see a camera, they feel like they need to perform. Little do they know that their acting and posing actually looks completely unnatural.

8. Wide Views of the Ceremony

Lens Selection

One thing I like to do at every church wedding is grab a wide shot of the sanctuary. I shoot this with a Nikon 14–24mm lens, a very wide-angle zoom.

Timing

The key to these shots is timing. Wait until there's a slow moment in the proceedings, then sneak to the back of the room and grab your shot. I tend to shoot during the homily (after the reading and before the vows) because I know that the priest or minister will likely be speaking for a few minutes. However, I also make sure I'm ready to switch lenses, in case they go into their vows sooner than I expect.

If you are working with an assistant, make sure that they remain positioned up front and covering the couple so you don't risk missing any emotional moments while you head to the

> "Wait until there's a slow moment in the proceedings, then sneak to the back of the room."

back of the church. For our coverage, Danielle stays to the right of the couple, kneeling down and facing the bride, the whole time I'm at the back of the church—just in case.

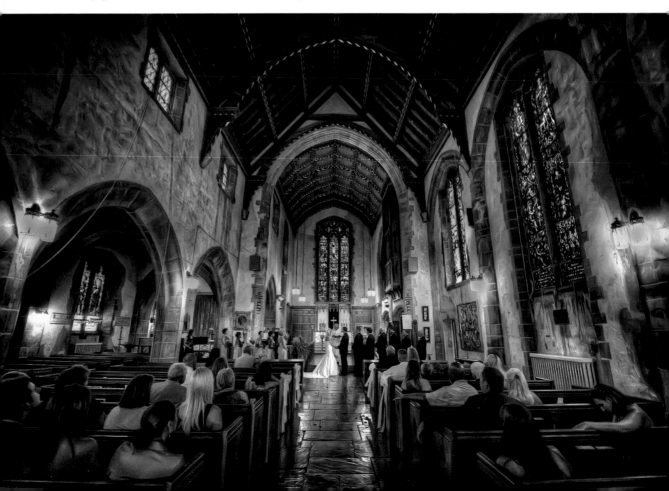

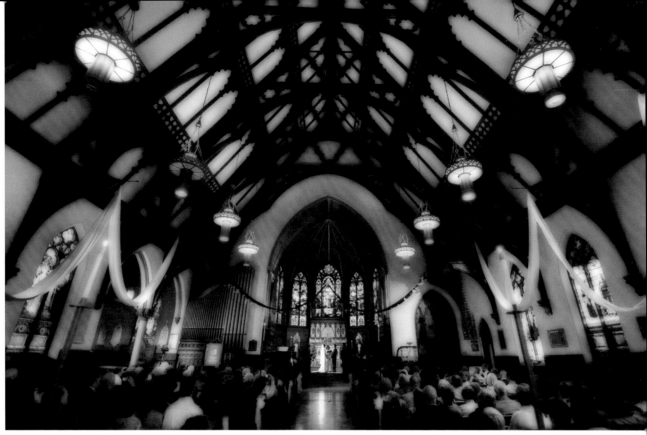

ABOVE AND FACING PAGE—I created each of these images from a single RAW, handheld exposure. For the shot above, I added some blur (masking out the bride and groom to keep them sharp) because the space looked quite busy and I wanted to keep the focus on the couple.

Take a (Very) Wide View

Panoramics (below) help capture the overall feeling of a large scene. To create them, I capture four or five RAW images with a wide lens. After enhancing each shot, I use Photomerge to combine them.

Try at Your Own Risk! To challenge myself, I've been experimenting with vertoramics (vertical panoramics), as seen to the right. Here, you see the entire roof of the church—from the altar at the bottom and rotating vertically 180 degrees up and over to the back of the church (upside down) at the top of the frame. Stitching these vertical shots can be very challenging—so experiment on your own time, not at a client's event.

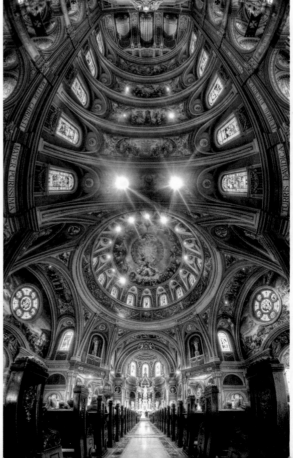

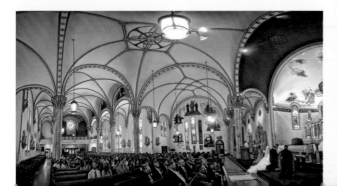

9. Closer Views of the Ceremony

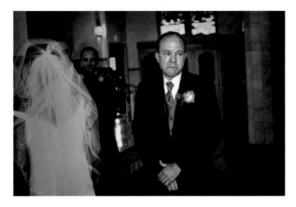

Lens Selection and ISO

Other than when shooting the wide-angle shot of the church (see previous section), my lens of choice during the ceremony is a 70–200mm f/2.8, which I currently use on Nikon D3s. This lens allows me to zoom in on the action from a respectable distance—but it's also wide enough that if something happens close to me, I can zoom out and the 70mm setting should do the trick. I tend to shoot anywhere between 3200 ISO and 10,000 ISO.

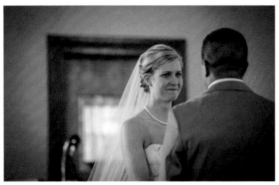

Lighting

I don't like to use flash at all during the ceremony. I prefer using all ambient light to show what it really felt like on the day of the couple's wedding. If the church was dark and intimate, then I want the clients to feel that same mood

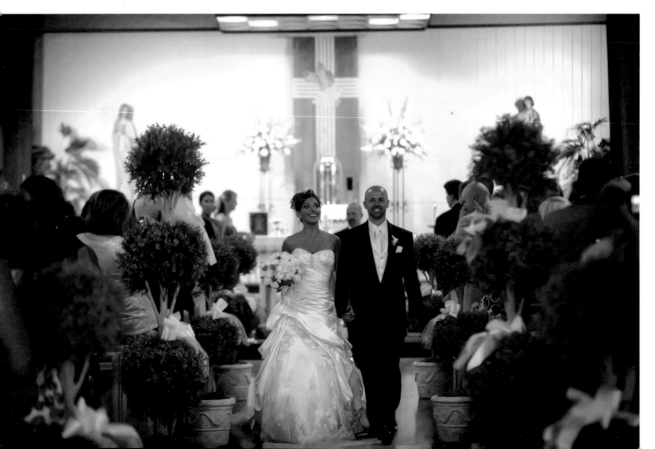

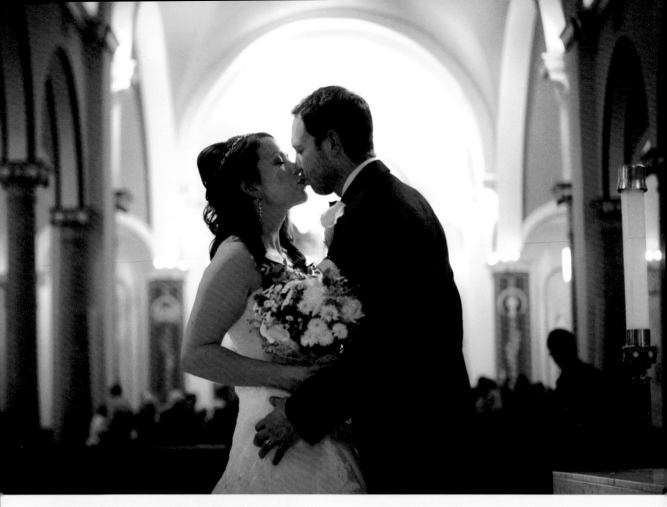

A Special Moment That Couples Love

As the couple is announced and makes their way up the aisle, I'm photographing them from the back of the church. When they get to the last row of pews, I stop them in the aisle and ask them to kiss. With ambient light coming through the doors, they are nicely lit—and the whole scene is visible behind them, lit up with a golden tungsten glow. It's a special moment for the bride and groom, and it's a shot every single couple loves.

when they look at their wedding images years down the road.

Be Courteous

Be considerate when shooting; guests and church officials will remember you for all the *wrong* reasons if you are a distraction.

There are lots of ways to minimize your impact on the event. For example, I try to time my movements to when people are standing or sitting (when they move, I move). When photographing the bride coming down the aisle, I stay behind the mom on the bride's side of the church, giving the groom a clear line of sight. I also stay low so I don't obstruct the brides-maids' view of the bride's appearance.

As noted in the previous section, I also shoot with ambient light during the ceremony. This is another way to avoid distracting the couple or their guests.

10. Family Portraits

Not Splashy, But Important

Traditional family photos are not fun for photographers, and they aren't something you'll probably splash all over your web sites and social network pages. However, that doesn't mean they aren't *very* important to your clients. In fact, clients sometimes ask, "My mom was wondering if you do formal family portraits? She didn't see any on your web site." I assure them that we certainly *do* take family portraits.

Planning

When I talk to the bride a week before her wedding, I remind her that I will be taking the family portraits immediately after the ceremony. If there is anyone outside of the immediate family that she wants in her images, I ask her to let them know they should hang back after the ceremony. If the bride seems overwhelmed, I suggest she put someone in charge (someone with a loud voice!) of getting everyone together for the photos—so she doesn't have to worry about tracking down Uncle John herself.

Grandparents First

During my pre-wedding consultation with the bride, I also ask her if any grandparents are

going to be in attendance. I'd hate to call for someone and learn that they are deceased. We photograph the grandparents at the beginning of the session because they are generally the first ones to leave. It's a long day for them. After their photos with the couple, we call in the parents and then the siblings. We do that for both sides of the family, and then let the grandparents go on their way.

Capturing the Family

It seems overwhelming, but once you get into the flow of things, you'll have no problem getting the family portraits done in ten to fifteen minutes. If, by chance, you do miss someone or someone leaves the church early and the bride seems concerned, just tell her that you'll be sure to get that person during the cocktail hour—and make sure you do it then (at the start of the reception) in case they also have to leave the party early.

Parents and Siblings

I like to start with the biggest groups, calling in the couple's parents, grandparents, siblings,

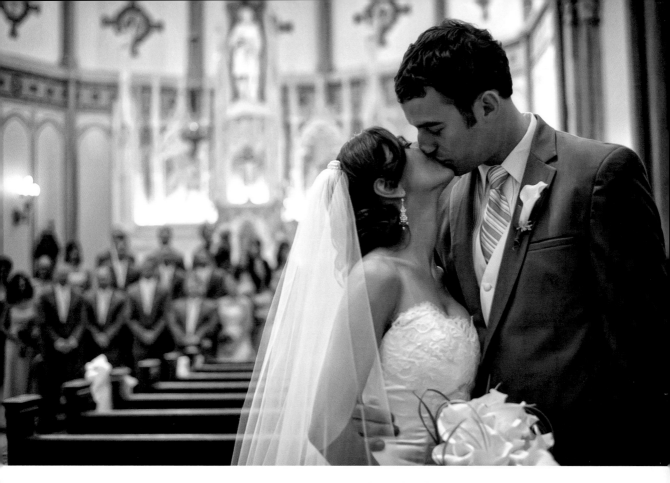

cousins, aunts and uncles, and nieces and nephews. Once the big groups are done (for the bride's side of the family and the groom's side of the family), I send everyone away except for the parents and siblings.

I pose the groom's parents and siblings with the bride's parents and siblings for shots of the two families coming together as one (as well as separate shots of the bride with her immediate family, and the groom with his immediate family). Then, I ask the siblings to step aside and get both sets of parents together with the couple. I will also photograph the parents of the bride with the couple, then the parents of the groom with the couple. Those sequences are repeated with the bride's siblings and groom's siblings.

The Bridal Party and Couple

Once I release the family, all I'm left with is the bridal party. I do the bridal party shots, then send them to the limo so I can work with the bride and groom alone in the church. I get a nice formal photo for Mom and Dad, then have them walk out of the church hand in hand. I follow them, getting a grand shot of the church with the bride and groom walking away. See the next section for more on this.

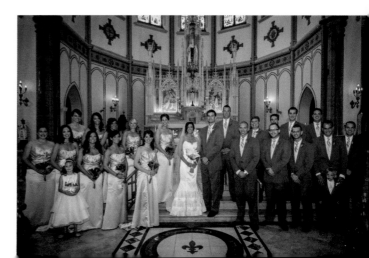

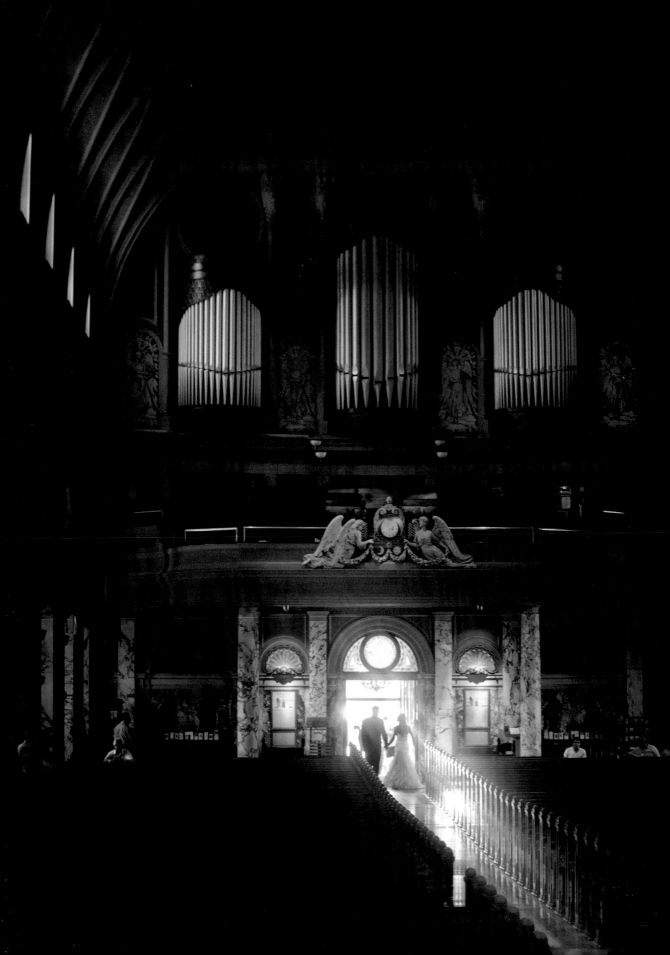

Study the Venue

Walk around your venues to get ideas for shots—and that includes the church interior. Before the ceremony, as I was getting set up, I started photographing details of this church and noticed an angle that I'd never really taken advantage of before with a bride and groom.

One Look

After the ceremony ended and we had finished all the family portraits, I had the bride and groom walk out of the church together. I positioned myself for the angle that I wanted and got the shot that I envisioned (facing page). The shot required no camera tricks and no special editing. I like how dark the back of the church is and how the light from the bright summer sun is beaming through the doors, putting a spotlight on the bride and groom.

A Second Moment

Once the bride and groom reached the doorway, I had them stop. I ran up to meet them and asked for a quick kiss. As shown below, the couple is pretty much in the same location—I just changed my own position and requested a different pose. This gave them two great shots that are entirely different.

Social Media

One great thing about connecting with clients on social media is that they often post photos of life inside their homes. In one of those posts, I noticed that the bride and groom have the second image in this series as a metal print, hanging above their fireplace. It's one thing seeing my images online as people's profile images, but it's very surreal to me to see my images hanging in people's houses in areas they see every single day. That feeling will never get old!

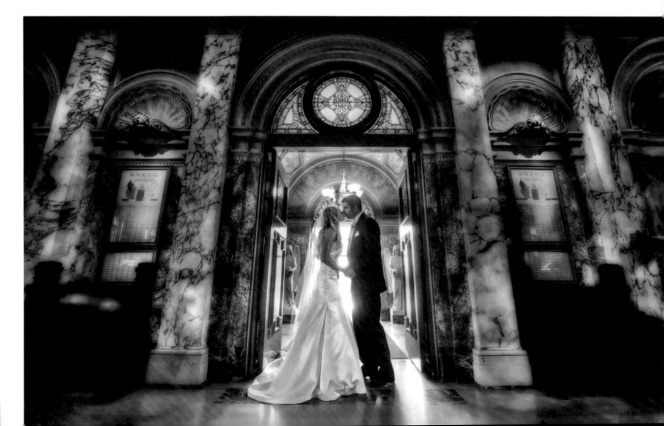

HDR Imaging

High dynamic range (HDR) images seem to inspire strong reactions among photographers. To me, HDR is a tool just like any other. I use it (or not) to whatever degree makes sense for the image I have in mind. It's that simple.

Before you leave the church, take a look around and see what the nearby areas have to offer in terms of backgrounds. Sometimes you'll find a cool piece of architecture, a rustic door, or even a field that you can make use of. You never know, so investigate carefully. These are opportunities you don't want to miss.

In the Field

For this couple's wedding (top right), we stepped outside after the ceremony and spotted a lush field next door. The couple was just about to get into their limo, so I simply pulled them aside to shoot a few images at the edge of the field. I didn't know exactly what I was going to be getting into at the location that was planned for the couple's location images, but I knew

BELOW—A golden field near the church set the stage for a backlit portrait of this couple.

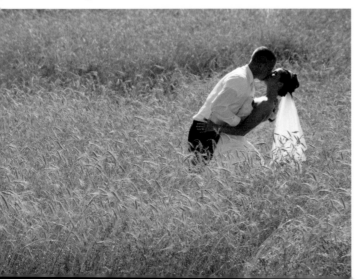

this wall of tall stalks would make a nice, simple background and I wanted to take advantage of it while we were there.

The image was shot with available light only—and it was direct overhead light at 1 o'clock in the afternoon. I metered for the dress to get all the details and bring down the overall

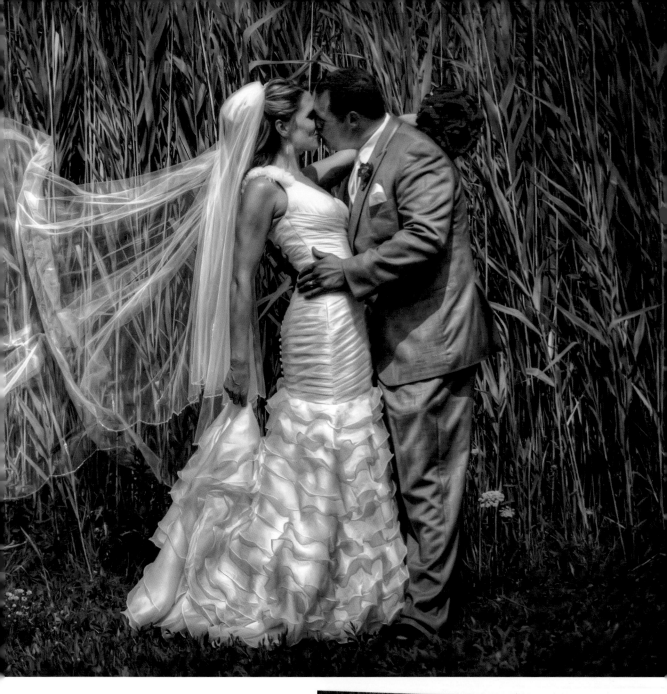

ABOVE AND RIGHT—The couple was initially posed with the wind at her back (right). For a more dynamic look, I turned her around so the breeze would pick up her veil (above).

exposure. Shooting RAW, I knew I'd be able to bring out all the needed tones and create the look I envisioned in postproduction.

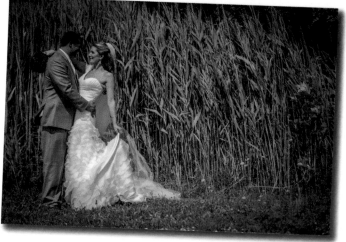

13. Themed Weddings

Building on an Idea

When a couple announces a theme for their wedding, they don't do so lightly. You can bet they've thought about it carefully and selected something that's meaningful to them. In your photography, you have the opportunity to pick up on that theme and add to the meaning of their images.

A Surprise Shot

In keeping with the "love is in the air" theme, the bride had made arrangements to shoot on a rooftop, and was sad when the plans eventually fell through. Knowing that, I arranged with the reception venue to let us shoot a few images on the roof during the reception. It was a treat to surprise the couple with a sunset shoot on the roof during their reception!

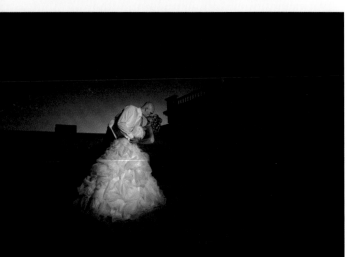

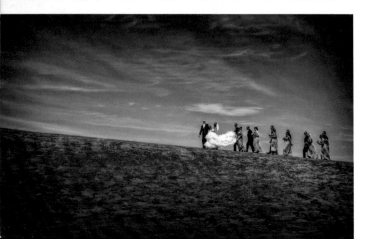

Love Is in the Air

This wedding's theme was "love is in the air." The couple got engaged in a hot air balloon—and we also shot their engagement session in a balloon. So when it came to a location for the images, I wanted something that had a similarly

airy feel to it. We chose a park with a big hill so I could shoot from below and get a lot of sky in the shot (and that's all we had to work with—grass and sky!). Fortunately, we had some very pretty skies that day. On one side of the hill, the clouds were high and wispy (as seen below). If I moved myself to the other side of the hill, the clouds were large and puffy (as seen to the right).

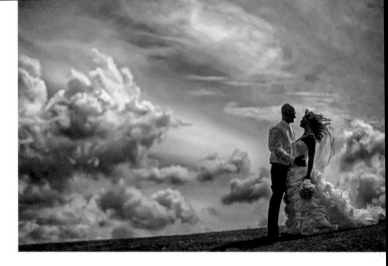

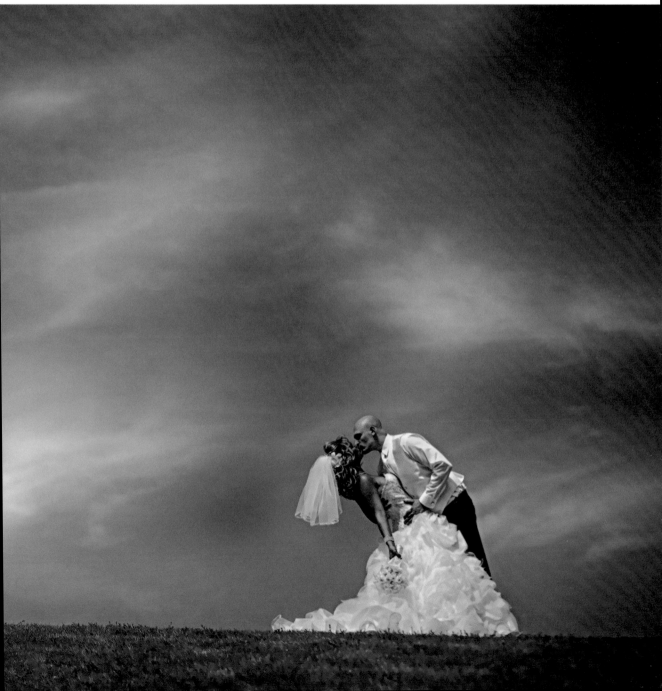

14. Location Selection

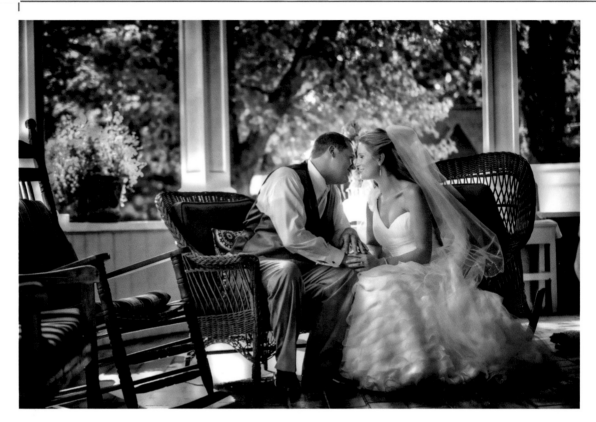

When it comes to deciding on locations for the wedding-day photo shoot, we leave the final decision up to the couple, but we do give them some ideas to think about. We ask the couple to describe what appeals to them.

"We ask the couple to describe what appeals to them. A cityscape? A village style?"

Is it an architectural cityscape? An urban look with graffiti? A small-town village style? A rustic look amidst barns or fields? Or a natural setting with waterfalls, streams, and beaches? Once the couple defines their style, we give them our ideas.

The bride and groom you see here were born and raised in the country but now live in a small village that has a lot of nice little shops. They reached out to a friend of theirs who owns a home just off the main street in the village and they asked if they could use her old colonial house as the setting for their pictures. The home was beautiful but still very uncluttered, which matched the couple's style.

I always tell my clients, "The more you give me, the more I can give you in return in your pictures."

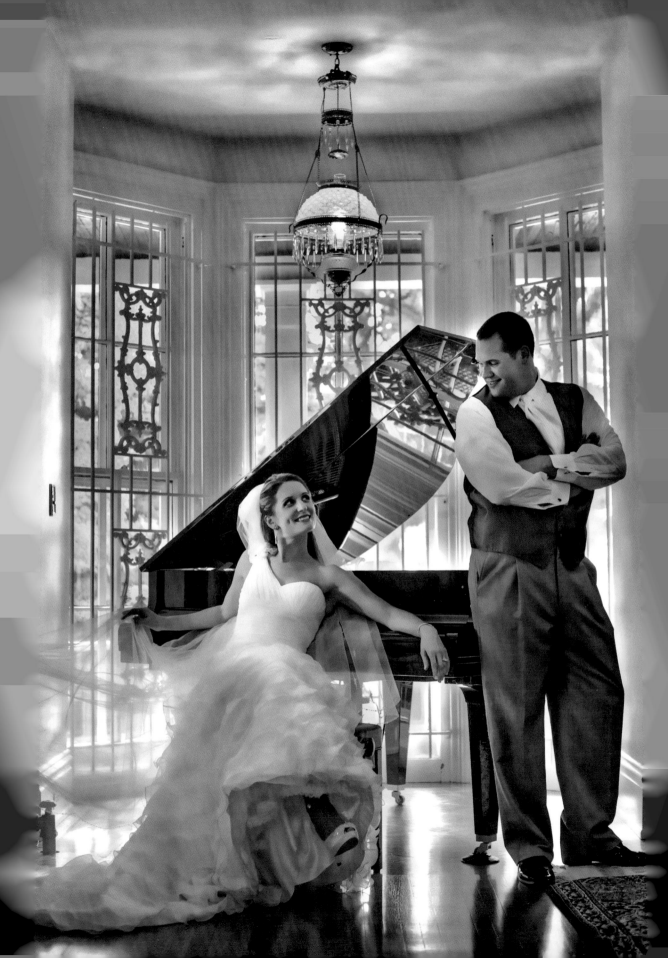

15. Maximizing Locations

Once you get to a location, make sure that you work around it from all angles. Identify every nook and cranny where you might be able to shoot. Study the light, put your subjects in the area, pose them, and take the shot—then move on to the next concept. If you do, you'll really surprise yourself with how many interesting shots you can get within a matter of ten to twenty minutes working just at one building.

Crunch Time

Getting used to working quickly and moving in an organized manner through a series of dif-

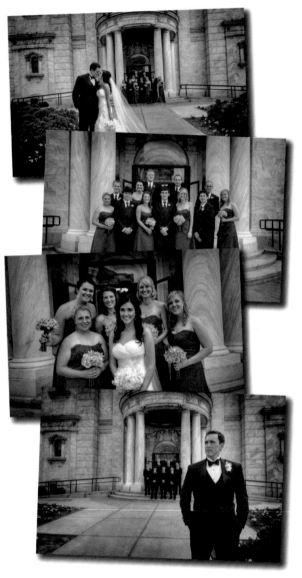

ferent background options at a single site will come in handy when you're really pressed for time. There *will* be weddings where you only have twenty minutes to get portraits done. If you make this approach a habit at *every* wedding, then you'll have no problem dealing with the pressure when the time comes.

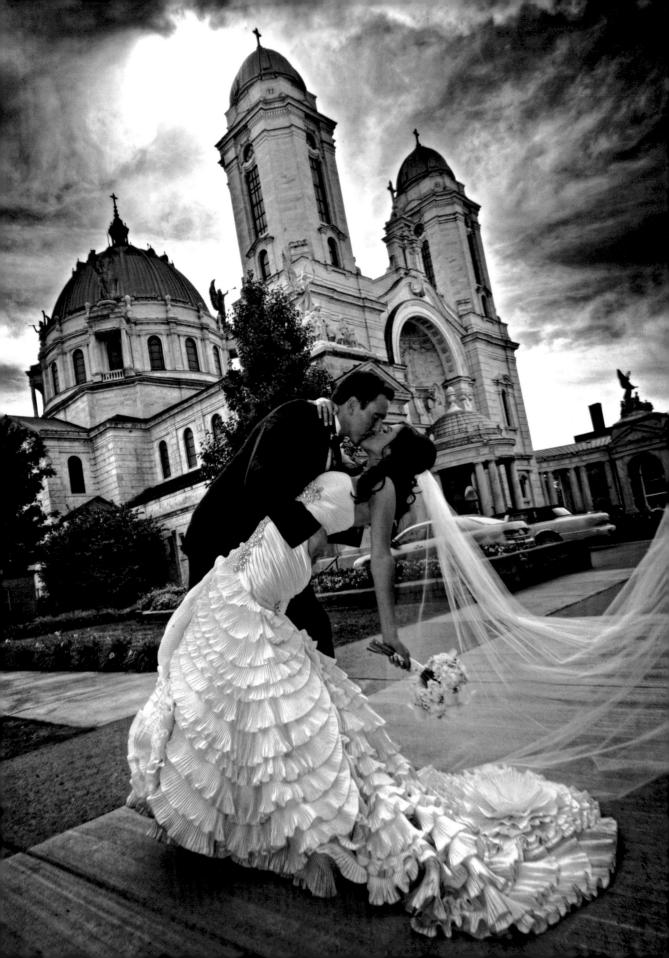

16. All the Details

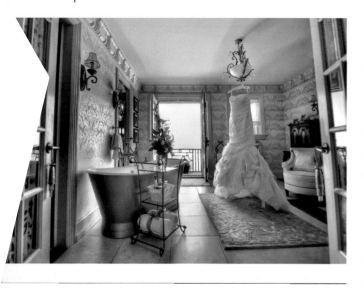

Details are a very important part of the wedding day. Couples put a lot of time, thought, and money into the small things that make their wedding unique—everything from the table settings and flowers, to the bride's shoes and jewelry. Given how much energy your clients have put into these elements, it would be a crime not to capture them all.

Shooting with Style

When shooting the details, consider the wedding's theme and colors, and be sure to find a good background. I tend to shoot with ambient light, but lately I've been using the Ice Light (as shown in the images on the facing page and below). The daylight color balance makes it easy to use—and it looks like a light saber (see section 25), so it attracts a lot of attention.

Get the Safe Shots, Then Experiment

While the bride is dressing, work on the "safe" detail shots. Later, if you come across something interesting you can experiment with more creative variations. For the photograph below, I experimented with putting the rings on the ice sculpture, where they left a perfect indentation after a few moments. I created a "Mickey" pattern to coordinate with the Disney-themed wedding that featured "hidden Mickeys" throughout the decor and details. (See section 55 for another example of a "hidden Mickey" I created for this wedding.)

17. Cars

Stylish and Chic

Everyone loves a nice car—especially the guys. We always try to sneak in a couple shots for the groom to appreciate. Wouldn't the wife be proud if her hubby wanted to put a wedding photo in his garage or man cave? Okay, that might be a stretch—but you never know! Cars are always fun to work with. They're stylish and sleek. As seen in these images, you can work with the colors and reflections. You can also use them as props, making it easier for the couple to pose in natural ways—or unexpected ones.

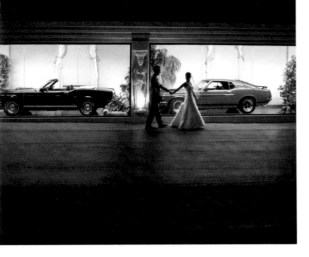

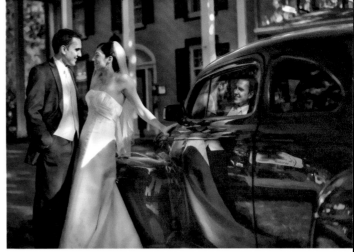

Veils in the Wind

As you'll see throughout this book, I'm infatuated with wind and long veils—and brides love this look, too. In fact, when a bride books with us, it's not uncommon for her to immediately purchase a long veil and start praying for wind.

I evaluate the wind's direction the same way a golfer does: by throwing blades of grass into the air. Then I turn the bride toward the wind and have her hold up the edge of the veil. When the wind takes it, I snap the shot (or a series of them in burst mode so I have a few to choose from). For the image to the left, I wanted the long veil to run the length of the car, so I positioned the couple near the back tire.

So what if there's not enough wind? This day it was windy—but not windy enough to pick up the veil and do something amazing with it. The wind needed assistance. Happily, this bride is a dancer, so she knew to give an elegant pose by kicking up her leg. That caused some air to move underneath the dress and veil, making them flow in the same direction.

See sections 20 through 22 for more images created using this technique.

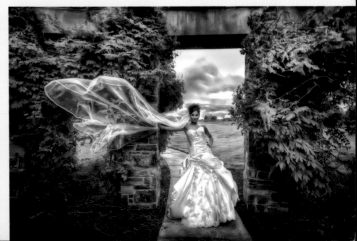

18. Composition

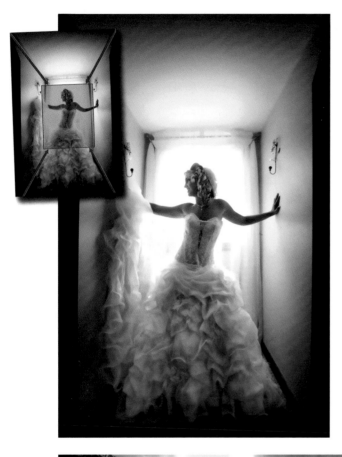

Leading Lines and Frames

Lines, found throughout the natural environment and the man-made world, are valuable tools for composition. Used correctly, they help direct the viewer's gaze toward the subject—something that is especially important in more "scenic" images, where the subject(s) may be smaller in the frame.

Off-Center Subjects

Probably the most widely used approach to composition is the rule of thirds. This guideline divides the frame into thirds, vertically and horizontally (as shown below). Placing the subject

LEFT—Leading lines from all four corners direct your eyes toward the bride. The lines of the window casement frame her from behind.

BELOW—The bride is positioned according to the rule of thirds (indicated by the blue lines). Leading lines also direct the viewer's gaze.

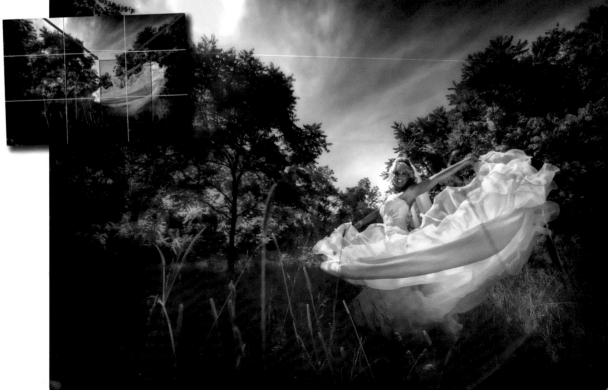

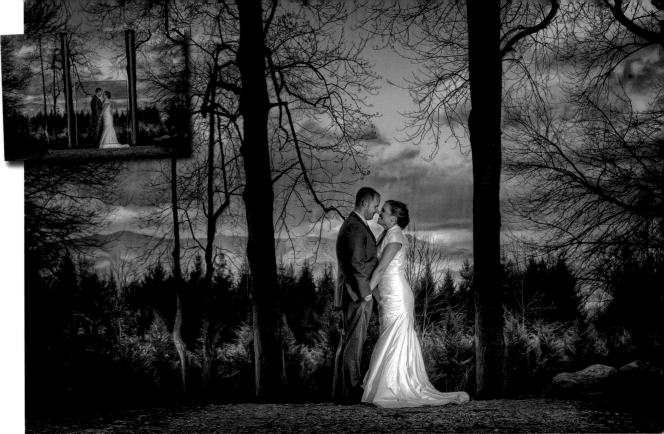

ABOVE—Framing the subjects between vertical lines keeps the visual emphasis right where it should be.

RIGHT—Symmetrical compositions often work well with centered subjects, especially with plenty of leading lines.

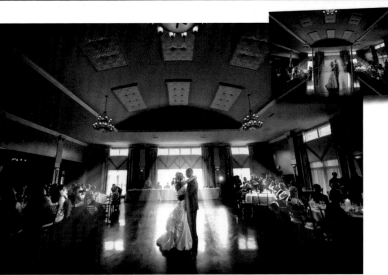

off-center along one of these lines or at an intersection of two lines helps draw the eye toward the intended focus of the image.

Centered Subjects

Photographers are often told to avoid centered subjects, but centering can work perfectly well. When I put my subject in the center of the frame, it's because the image is appealing with the subject in that position and they remain the focus of the image. In the black & white image above, for example, notice how the bride and groom are centered but all of the lines in the image direct your eyes toward them. Your eyes go first to the bride and groom, then begin to study the rest of the image.

19. The Right Location

Choosing the right location for the wedding portraits can make a huge difference in your results. In some cases, the location can be chosen purely for its look; in others, a special connection to the couple determines the right choice.

Familiar Is Not Special

If you live in a city, there are probably a few popular locations that you can count on to be flooded with weddings and photographers every weekend. Some spots are so popular, you have to wait your turn to shoot! Unfortunately, watching another bride's photo session will *not*

> "Watching another bride's photo session will not make your bride feel special, or like it's 'her' day."

make your bride feel special, or like it's "her" day—or that her wedding images are going to be different from anyone else's.

A Special Look

This image was created on an old cobblestone street with some brick buildings as a backdrop. I love the old-school street lamps in this neighborhood (a bit cropped out of the shot, but still visible in the shadow). I covered the couple with the veil, which glowed when it was lit up by the sun. This shot screamed out to be presented in black & white, giving it an old European flavor.

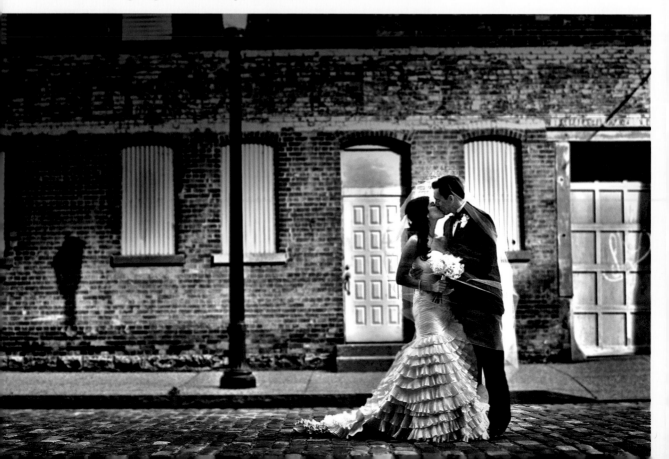

A Meaningful Location

The bride and groom shown to the right were married at a church that the groom's grandfather helped build (bottom photo). He was also put to rest at the cemetery next door (top photo).

The couple didn't tell me until the last minute that they were going to go pay respect to their loved one at the cemetery. My instinct was to give them their space and not photograph it, but I put my 200mm lens on just in case. From far away, I kept my eye on them. When I saw them reach for the monument, I grabbed one frame. I'm not sure if they even knew I took the shot at the time (although they probably heard the thundering sound of the Nikon D3's shutter). It's important to be respectful and to remember to lay low sometimes—but you should always be prepared to get the shot.

Get Out There and Find Something New

If you find yourself going to the same locations over and over again (and probably doing the same shots you've taken a hundred times before), it's time to start looking for some new shooting areas. I'm always searching for interesting locations where almost no one else goes—and on the rare occasions that I *do* encounter another wedding, I'm prepared to move on and shoot at another site.

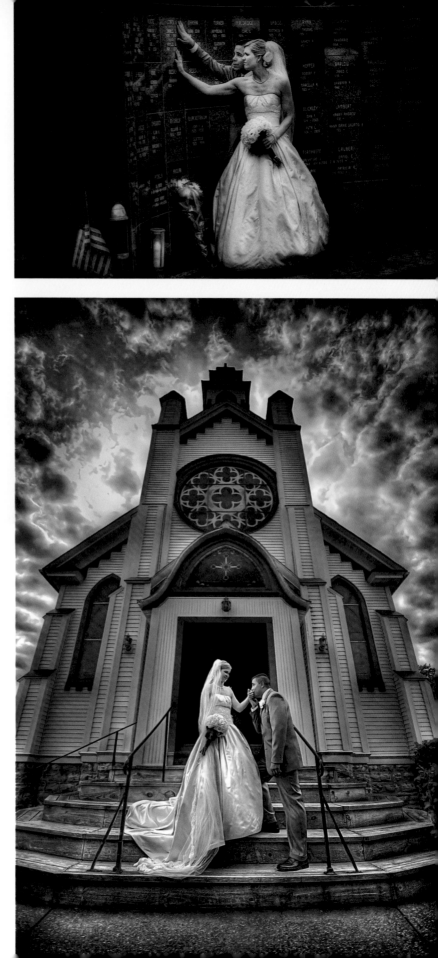

20. Windy Days

Adding Some Movement

As I mentioned in section 17, long veils and windy days are a great match. However, nothing annoys me more than seeing other people hold up the veil to get the shot. It's magical when the wind takes the veil all by itself and does something extraordinary with it. If the wind needs a little encouragement, having the bride lift the edge of the veil often does the trick.

A Special Location

The photo on the facing page was taken at Our Lady of Victory Basilica in Lackawanna, NY.

Showing the veil in the wind is a popular look among my brides.

This was early in my career and it was my first time shooting at this magnificent church, which is said to rival the churches in Italy. I definitely wanted to take advantage of everything it had to

> "I noted which way the wind was blowing and faced the bride into the breeze."

offer, inside and out. As we were leaving, I decided to take the bride and groom to the corner of the street to try and get the entire church in the background at an angle. I noted which way the wind was blowing and faced the bride into the breeze.

I asked the groom to dip the bride, and as he tipped her back, she held her veil with her left hand (out of view). That created a pocket for the wind to get under and pick up the veil like a sail.

Postproduction

Again, this was early in my career when I didn't have as many tools to work with. I shot it with a 18–55mm DX kit lens on a full-frame sensor. In postproduction, all I had to do was crop out the natural vignetting from the DX lens. I converted the shot to black & white using Nik's Silver Efex Pro. The skies were very blue in the shot, so I played with the blue filter to turn them almost black, a nice contrast to the white church and the clouds in the sky.

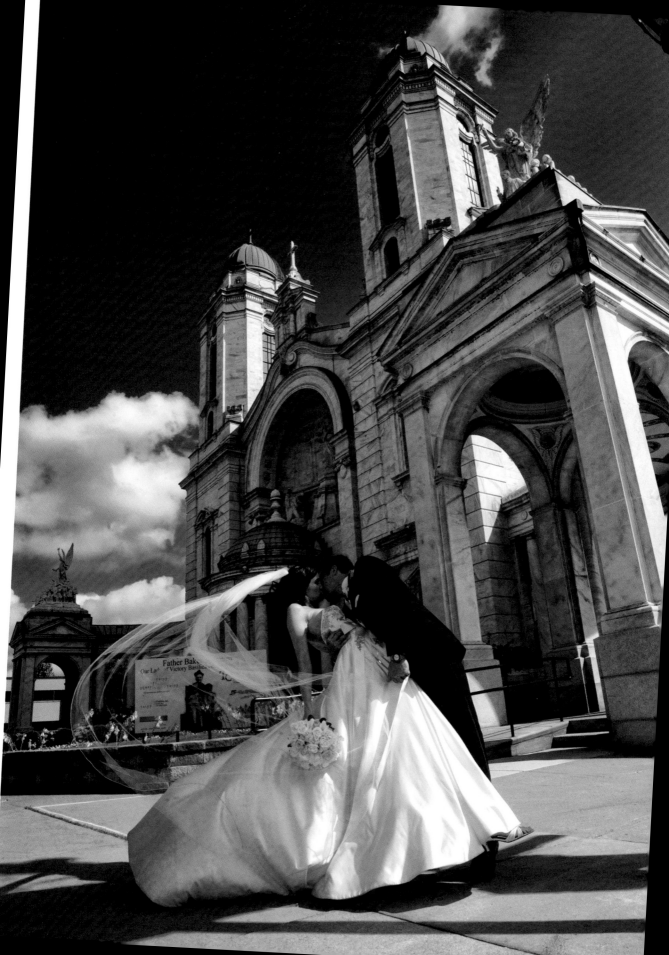

21. Stormy Days

A Life-Changer

The shot below changed my life. The story began on a Monday morning. I had just wrapped up a wedding on Saturday and was starting to look forward to the next one, so I glanced at the ten-day forecast to see what I was in for. In early September, the summer heat is usually

In 2012, *Rangefinder* magazine selected this image as a feature for their popular "RF Cookbook" series.

wearing off, so we anticipated comfortable shooting. Unfortunately, Hurricane Earl had other ideas. The tail end of the hurricane was projected to hit Buffalo on the wedding day, so we were looking at the potential for 50–60mph winds, a lot of rain, and some tropical temperatures. There was no hiding from it.

The first thing that popped into my mind was to plan for some indoor locations. Unfortunately, it had been a rainy year, so all of the indoor locations had gotten smart and started charging couples—and requiring advance bookings. That Monday, I'm sure almost every bride and photographer were on the phone trying to book those indoor spots.

I came up with a couple alternate plans and gave the bride a call. After reviewing the basics,

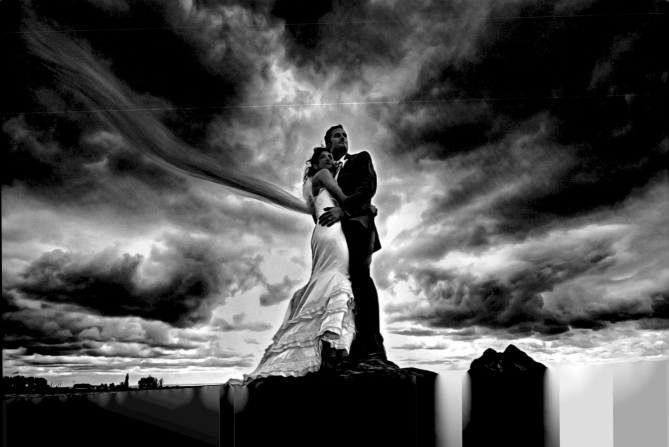

it came time to ask where she wanted to go for portraits. She nonchalantly replied, "The waterfront." The shore of Lake Erie is the last place you want to be when a hurricane rolls in, so I reminded her about the storm. She didn't seem too worried but sensed that *I* was concerned and said she'd shoot wherever I thought was best—but she really wanted to at least stop at the waterfront, even if we had another location in mind.

At the Church

We made it through the ceremony and did the portraits on the altar, but then it was time to go outside (the part I was dreading). Immediately, the bride's veil took off in the intense wind! The clouds were very dark; it was mid-afternoon, but it felt like the sun had already set. The rain started to come down, but it felt like a strong mist, so I shot the couple outside the church (and got a killer image of the veil that you'll see in section 22).

The Waterfront

I asked the bride if she still wanted to go to the waterfront—really hoping she would say no. Instead, she said, "Yes—I'm sure you'll get something good!" I'm glad *she* was so confident in me, but I definitely wasn't feeling the same way. I mean, how often does one shoot a wedding in a hurricane and make it look good? It was time to man up and do it.

On a normal wedding day, the waterfront is loaded with other couples getting photos taken, but we were the only crazy ones there that day. As we walked to the rocks, the groomsmen carried umbrellas that were literally breaking under

Great images don't require great weather.

the force of the wind. The groom kept a tight grip on the bride so she wouldn't blow away.

Posing and Lighting

We got to the rocks and I had them sit down. When I looked at my camera, I fell in love with the sky and the background, but I hated their pose—it needed to be as dramatic as the sky, so I had them stand up. I had the groom hold onto her as if her life depended on it. Her veil

"If the weather isn't perfect, we'll take advantage of whatever nature gives us!"

was almost ready to fly away, so I tucked it under his hand. I had my assistant hold a flash behind me to the right and snapped away. I took a series of shots and they were all keepers. The action of the veil was unreal.

Now, when I see bad weather in the wedding-day forecast, I can't help but get a little excited. I always tell brides and grooms that if the weather isn't perfect for the wedding, we'll take advantage of whatever nature gives us!

22. Burst Mode

In the previous section, I showed you a portrait made at the shore in hurricane conditions. To the right is the shot that helped ease my mind and build the confidence I needed to shoot portraits in those conditions. In 2012, it was listed among *Rangefinder* magazine's "Favorite Images of the Year."

A Bit of Shelter

After I had stalled as long as I could in the church, we went outside for some shots. The rain had started—and while it was misty, it flew in your face at 50mph and stung. I took the

Images from the burst-mode sequence.

bride to the side door of the church to grab a little bit of cover from the rain and wind.

Rapid Shooting

The building blocked the rain, but the wind was intensified—as if she were in a wind tunnel.

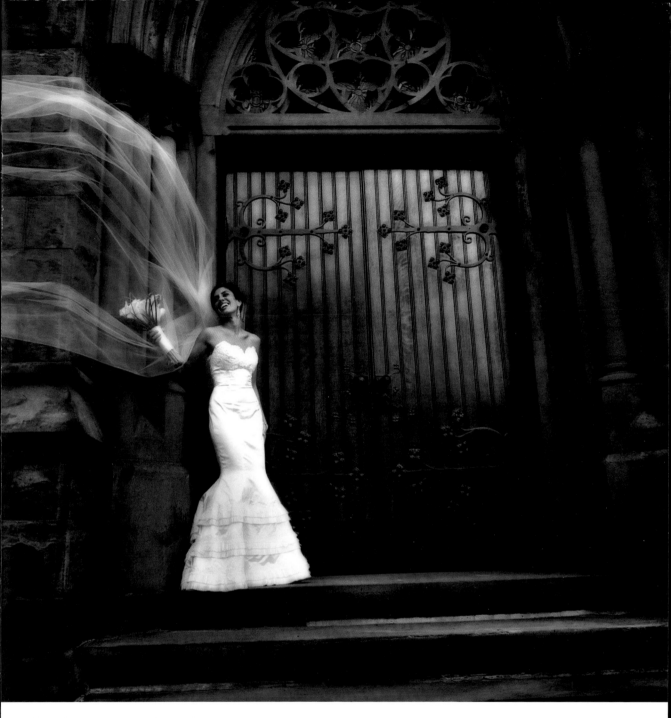

Standing next to the bride, I saw her veil flow violently in the wind. It was out of control! I quickly stepped back to capture it, putting the camera on burst mode to record 9 shots per second. I created forty or fifty frames of this series, each with the veil blown into a different position, so I could pick out my favorite. I chose the one where the veil was nearly flat against the wall—a look that would be impossible to fake.

Expression

The bride's expression is what makes this photograph so special. I think most brides in this situation would have had an "Oh no! My veil and hair are getting ruined!" face. This bride, on the other hand, seems to be thinking, "Holy cow! Look how awesome my veil looks!"

23. Assistant Shooting

Having an assistant to work with you on the wedding day is extremely helpful and ensures better results for your clients. For really high-end weddings, we sometimes even bring in a third shooter.

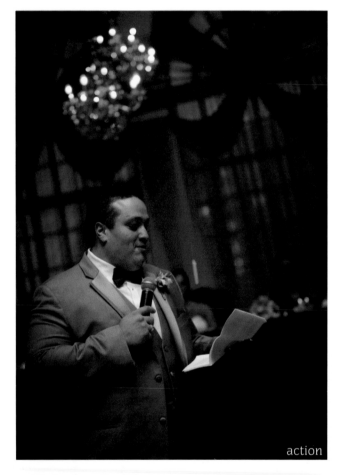

action

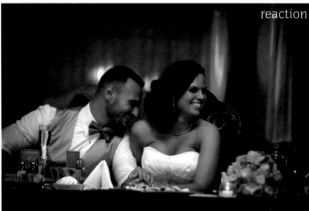

reaction

A Woman on Your Team

For male photographers, having a female assistant can offer significant advantages. When arriving at the bride's dressing area a male/female team seems to put the ladies at ease. Additionally, it's more acceptable for a female shooter to peek into the room and check their progress as the women are getting dressed. It *has* happened that the ladies forget to let me know they're done; having someone to check their progress can help keep the day on schedule.

Particularly if she is knowledgeable about fashion, a female assistant or second shooter can comfortably assist the bride with styling (making sure the dress, veil, hair, etc. all look great) while the primary photographer focuses on the "big picture" elements of the setup. She can also help pick out important elements of the bride's attire and accessories for detail shots.

Another Set of Eyes

Working with a second shooter also helps ensure you won't miss key images. An extra person who can help remember that you still need a shot of Grandma with the bride, individual shots of the groomsmen, etc., is a huge asset.

As discussed on the facing page, additional shooting perspectives and angles of view are also valuable. The more variety you can offer, the happier your clients will be.

Finally, remember that for every action, there is a reaction (as seen to the left). With the primary shooter focusing on the action, the assistant can document the responses.

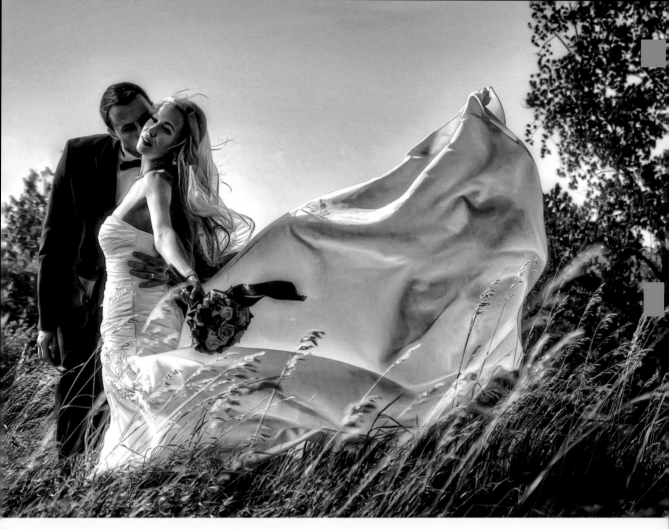

Additional Perspectives, Additional Opportunities

My wife and I work together, but not side-by-side. We want to increase our shooting opportunities, not duplicate each other's images. Wherever I am, she is working from a different angle. If I'm shooting with a long lens, she is shooting wide-angle images. For this scene, Danielle was down in the trenches, shooting up close and personal. I was up the hill, shooting wider views. When the wind picked up the bride's dress, our results were both nice—but Danielle's view (top) produced the better image. It's a shot we wouldn't have gotten without coverage from a second perspective.

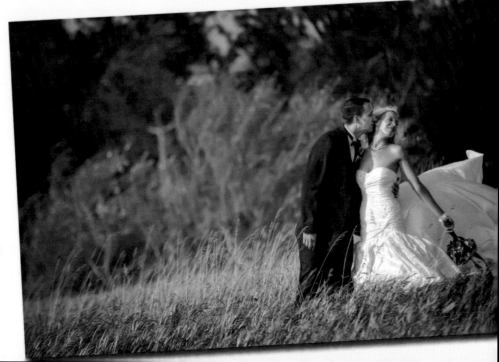

24. A New Look

"That" Location

Every city in America has "that" location—the one where *everyone* goes to get their photos done. I, for one, like to stay far away from those locations. It really doesn't feel like it's the bride's special day when she sees twenty other brides lined up to take photos.

Make It Special

In this case, the reception itself was being held at one of those very common locales, the 1880s lakeside casino seen in the background—so there was no getting around using it. I knew,

Two behind-the-scenes images from the creation of the master shot.

however, that I could get some different shots that not everyone else gets at such a popular location, so I was excited.

During cocktail hour, I was doing my detail shots of the room and noticed some old black & white photos of the building from the early

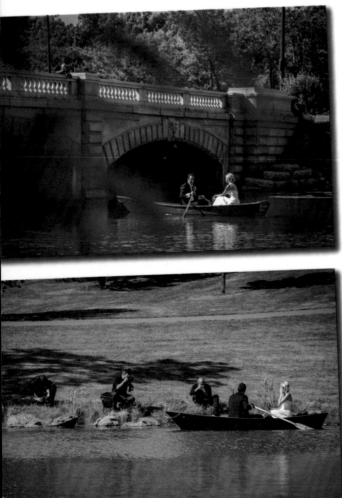

1900s. One in particular inspired me, and I decided to re-create it with the couple.

Shooting

This shot was taken during cocktail hour, so all of the other weddings had cleared out of the area. We were also shooting at sunset, so we had better lighting than all of those other weddings that were photographed here earlier in the day.

Both of those factors helped my image stand out from others at the location.

To replicate the angle of my inspiration image, I also had to walk quite a distance around the lake. And how about some kudos to the groom for rowing all the way out there so I could get this shot? It was a hot day, so I felt bad—but I kept telling him that it would be worth his effort, and it was!

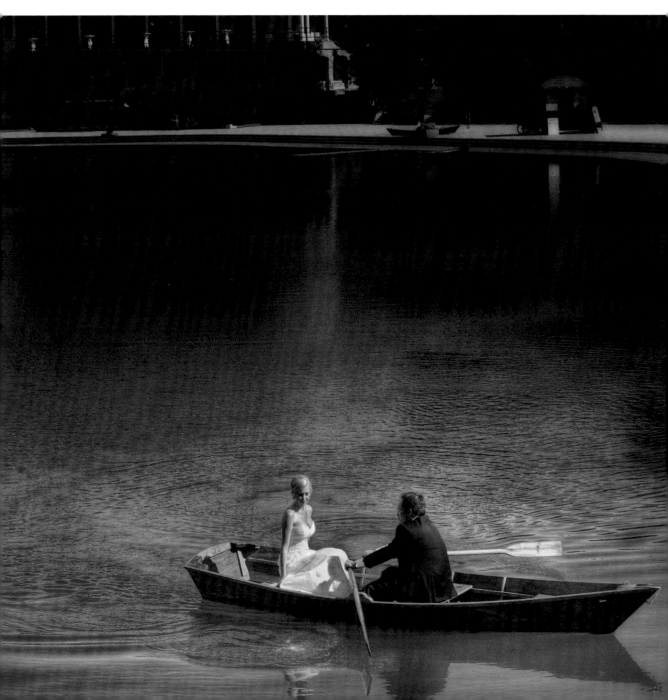

25. Twilight Hour

Location

This image was created at the same location as the previous photo—and you can see why it's a popular spot for wedding photographers. Again, at the popular spots, it's helpful to seek approaches that will make your work stand out. This twilight shot does just that.

Prepare the Couple

I always warn the couple that if we have a nice sunset, I might pull them away from dinner. If there is a nice twilight hour, I might pull them away from dancing. I always give them the option to tell me no, but I can be pretty persuasive when I see a great photo opportunity.

TOP—Danielle holding the Ice Light in position. **BOTTOM**—The Ice Light and accessories. Image courtesy of Westcott.

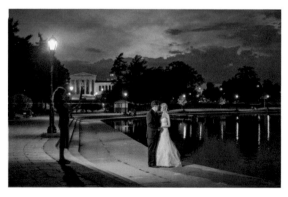

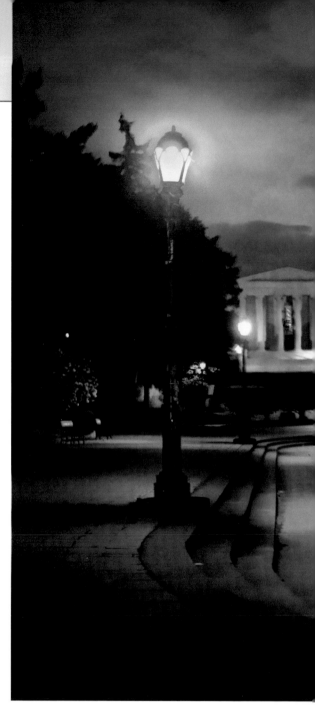

Color Temperature

At twilight, the sun has set and the skies are nice and blue. If you have tungsten ambient lighting in the area where you are shooting, you can use it to warm the rest of the scene just a bit. Here, I love the mixture of temperatures from the

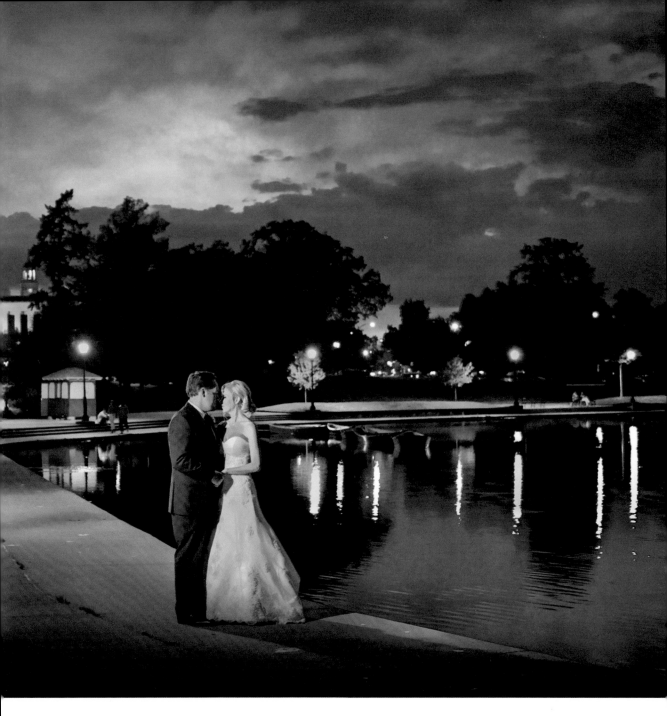

cold blue skies to the warm, golden tones of the street/building lights.

Adding Light

When it gets this dark out, we often need extra lighting to properly illuminate the couple. In this case, I set up the shot with my camera on a tripod. I then took one shot with Danielle in the frame, positioning the Ice Light on the couple. After she moved out, I took a second shot with just the ambient light. I mixed the two exposures together for one perfect shot.

26. Location Scouting

Postproduction: Beams of Light

To capture a starburst of light rays like those seen on the facing page, you need to shoot with the sun behind the trees. It also helps if the atmosphere is a bit hazy (dust, smoke, mist, or fog will do). Shoot in a shaded space where the sun is peeking through and you'll have magical sunbeams.

If it doesn't all come together in-camera, you can use Photoshop to add the look to any sun-through-the-trees shot. Here's how:

1. Start by duplicating the background layer.

2. On the duplicate layer, go to Image > Adjustments > Threshold and move the slider to the right until you see the white poking through the tree. Hit OK.

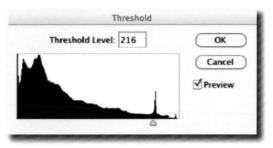

3. Choose a brush (black, 100 percent opacity) and black out any other white objects that remain, leaving only the white through the tree.

4. Set the layer blending mode to Screen.

5. Go to Filter > Blur > Radial Blur. Choose Zoom and 100 percent. In the Blur Center preview, click and drag to place the center of the blur over the sun in your photo. Click OK.

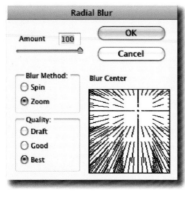

If you want longer beams, duplicate the layer and repeat the filter process until you have what you want.

Location, Location, Location

Scouting locations is one of my favorite things. I get in my car, crank up the tunes, and drive around looking for unique new shooting areas. If you live in a smaller city where there are a lot of photographers and you want your images to stand out from the competition, it's especially important to get out and scout. Even if the bride and groom choose a popular location, I like to peek around the area to see if there are any other angles or backgrounds we can use.

Find an Alternate

The photo on the facing page was shot at a popular location—so popular that there were three or four other weddings shooting there at the same time. Instead of waiting our turn to get the popular building in the background, we walked around and found a tree where we got this beautiful shot. Once we were done shooting at all the surrounding areas, we almost didn't need to shoot at the "main" spot. But, by that time all, the other weddings were gone and we had the entire place to ourselves.

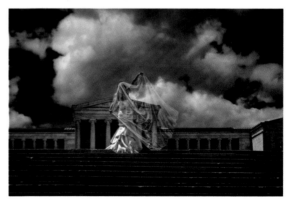

You'll often see multiple weddings lined up to shoot at this art gallery's colonnade (seen in the background). Shooting from a lower angle, up the stairs, created a unique look for this bride.

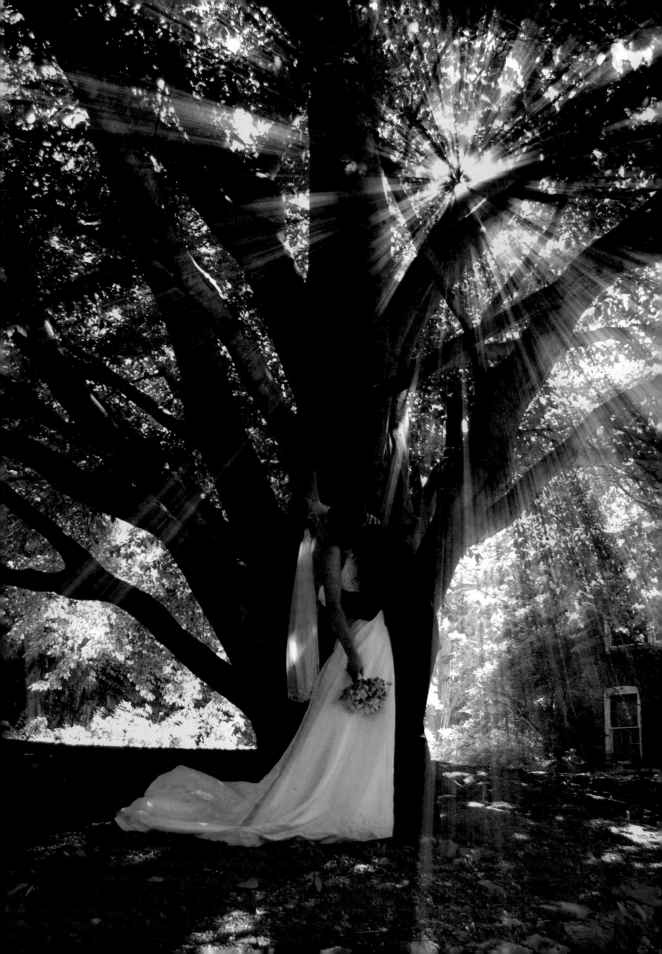

27. Same-Sex Weddings

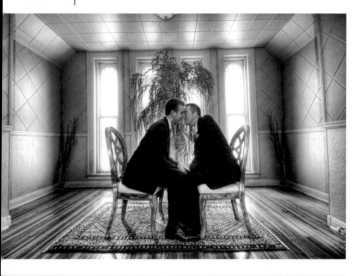

Love Is Love

Same-sex weddings are great for the wedding industry. The couple seen here initially hired us to photograph just their reception party because they needed to go out of state to legally exchange their vows. As luck would have it, however, same-sex marriage was legalized in New York State just before their wedding date. That meant they could rework their plans and hold the ceremony at home in front of all their friends and family.

It was one of the most emotional and happiest weddings I've ever worked. Everyone was overflowing with joy and it was simply a beautiful celebration of love. During the ceremony, there wasn't a dry eye in the crowd. It was a day full of emotion, and as a photographer it was a dream to shoot.

Posing

When you have two grooms (or two brides), the familiar bride-and-groom poses generally won't work. In this case, I wanted to make sure that the grooms looked equal and masculine. Fortunately, their connection was so strong, I was basically able to just let them be themselves, then provide simple instructions to refine their positions ("Turn your face a little to the left," etc.).

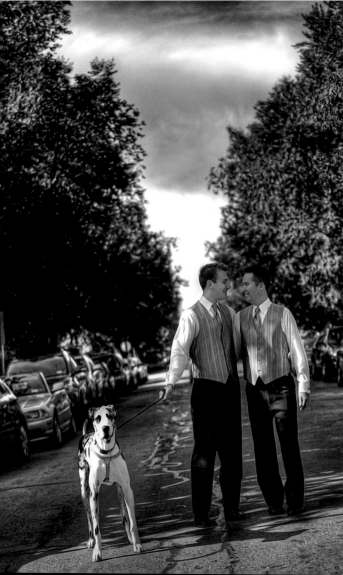

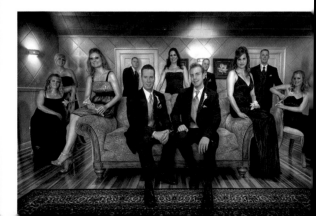

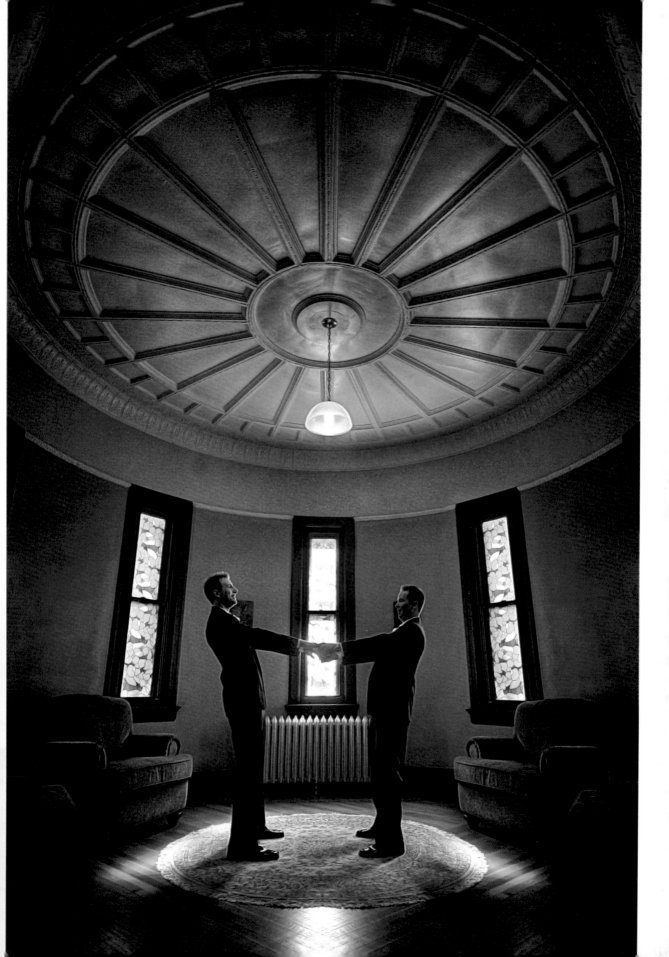

28. Two Portraits, One Room

Preparing to Shoot

Especially if I've never been there before, when we arrive at a location for photos, I ask everyone in the wedding party to hang out for a couple minutes. This gives me time to walk around very quickly and gather all of the information that I need for the photo shoot. I'll make mental notes of where I can take group photos and then individual photos.

Order of the Photos

I like to start with group photos and then send the bridal party away. Then, I'll work with the bride and groom, so that they are alone with us and again—without a crowd of their exuberant friends watching them. Finally, I will steal the groom away from the bride (and vice versa) for some alone portraits. I do this so that they have some surprises when they get their photos.

Hotel Room

The images on the facing page were shot in a small hotel room. Usually, I would move the table aside and out of the shot but I noticed that this table created a nice reflection, so I took advantage of it. I'm a sucker for reflections and use them whenever I possibly can—as long as I don't overdo them. (See section 47 for more on this.)

HDR for a Purpose

HDR photography has always been controversial, probably because people tend to overdo it and produce psychedelic-looking images that are hard on the eyes—which is pretty much the exact opposite of what we want to achieve!

> "I noticed that this table created a nice reflection, so I took advantage of it."

I use HDR processing when it will enhance the image by pulling out more color and detail. Not every image needs it. Here, the original images (left) were kind of "blah." Using HDR enhanced the colors and details. I masked in the original skin tones to keep the subjects looking real and natural, while everything around them is somewhat surreal and beautiful.

The non-HDR versions of the same images lack the drama and appeal of the final versions.

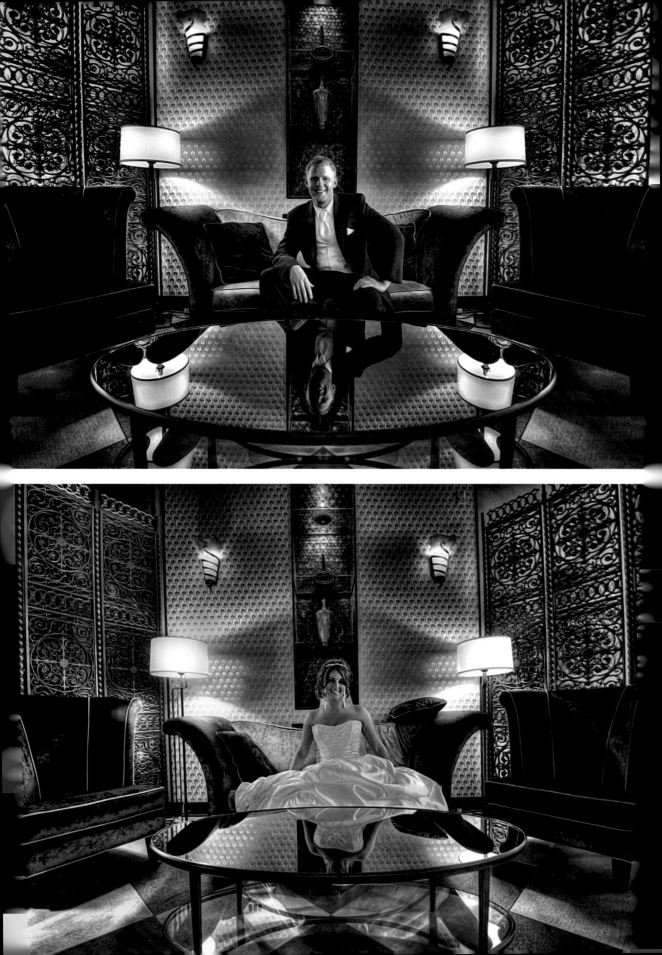

29. Color of Light

Warm and Cool

Playing with color temperatures is fun. Inside this abandoned train station, it was quite dark but there was a bit of sunlight coming through the windows. I used an unmodified Lowel tungsten light on a stand to illuminate the bride, warming her up a bit. I set my camera's white balance to tungsten, which gave the rest of the image a beautiful blue tone.

Old Places

When you enter old places to shoot, you never know what you're going to find. Luckily for us, there were some old cases left behind so we used them as props.

Getting permission to access old buildings like this often requires providing your business insurance information. Building owners want to make sure that if anybody gets hurt, it's on *you*. We always carry a copy in our camera bag and a digital copy on our iPhone or iPad. It would be a shame to show up to the bride's dream location for photos and not be allowed in because you didn't have your proof of insurance.

The scene with ambient light only.

When I am the one who will be held legally responsible for my clients, I like to leave the wedding party behind for images made in any location that is at all dangerous. The last thing I need is a drunk groomsman showing off, climbing scaffolding in slippery rental shoes, and

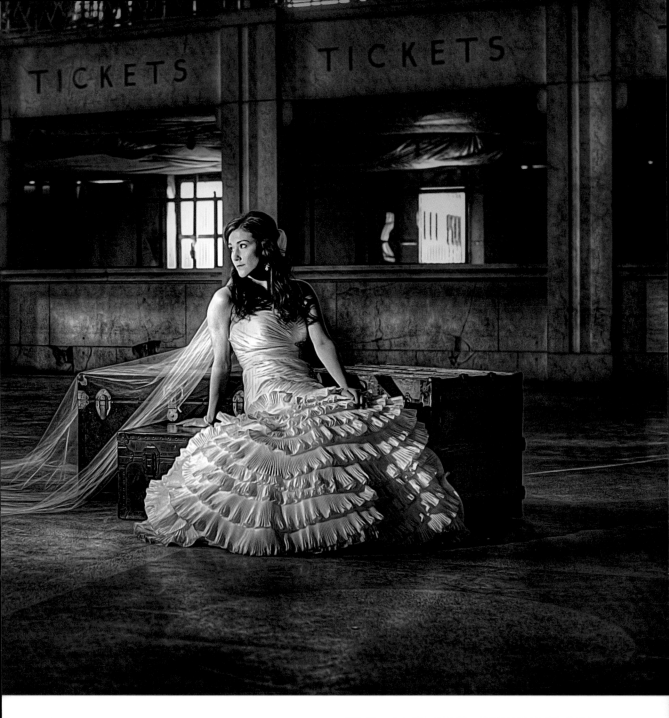

breaking his neck. To keep that from happening, I start by photographing the whole bridal party outside the location. Then I bring just the bride and groom inside for additional images. As always, you have to C.Y.O.A. (Cover Your Own A**)!

ambient sunlight on scene

Lowel tungsten light on bride

Golden Hour Plus Shade

I love shooting in the fall. Here in New York, the hot and humid summer months are done, so it's comfortable weather for chasing after bridesmaids and groomsmen. The colors on the trees are also beautiful. But what I like the *most* is that the sun sets earlier in the day.

Couples usually have their portraits taken in between the ceremony and reception—so we're shooting around 2–5PM, when the summer sun is high and produces ugly lighting. In the fall, the sun sets between 4PM and 6PM, so I let brides know that if they can plan their ceremony to end around 3–4PM then we'll have perfect golden-hour lighting for their portraits.

The image below shows the golden sunlight shining through a shaded area I was standing in. I used HDR on this image to bring out the contrasting cool colors in the shaded stone area and to add some detail in the area of sky seen in the background.

That pairing of the golden, sunlit colors meeting up with the cool blue tones in the shade gets me every time.

Choose Your Light Source

You have to think through your lighting for each setup (see sidebar to the right). For the image on the facing page, flash would not have been a good option; it would have been too cold and lacked the spotlight effect I needed (absent a modifier for that look). A reflector was also out of the question because there wasn't any light available to bounce onto the bride.

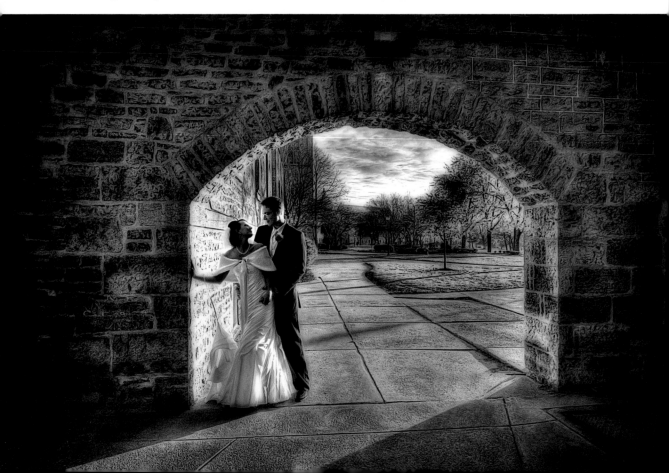

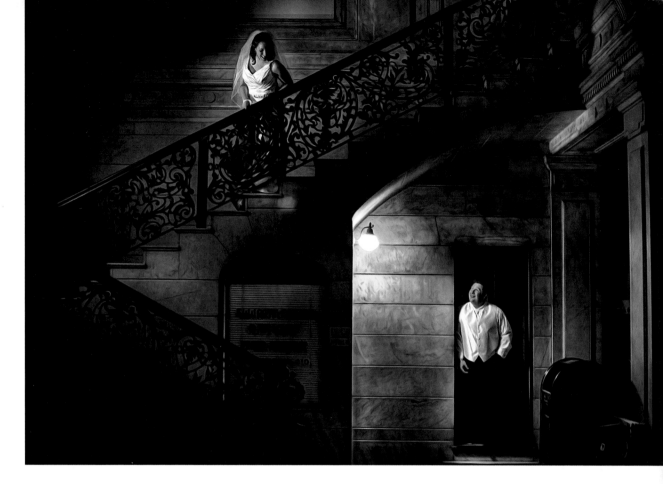

Lowel tungsten light on bride

existing tungsten light on groom

LEDs would have been feasible, except that the units I was using at the time weren't powerful enough (unless the light had been placed a couple feet away from the bride and in the shot).

My choice was a tungsten Lowel light to create soft, warm light that brought the bride out from the blue shadows and produced nice color on her skin.

Light Sources: Pros and Cons

FLASH. I like the power of flash units but sometimes the light is hard to control and spills everywhere. It also tends to be obvious; I know exactly where the flash was placed when I see a flash-lit shot.

LED. LEDs have long-life battery power, plus they're small and lightweight. However, the color temperature of the light can be hard to control (but this is getting better and better on newer models).

TUNGSTEN. Tungsten lights are easy to control but give a warm orange color that you sometimes don't want. The battery packs are heavy and the light gets hot.

REFLECTORS. Bounce boards can give you quick light in a hurry—especially with an experienced assistant who knows how to bounce the light correctly onto your subject. Otherwise, you're going to spend more time adjusting the reflector than shooting. That's inefficient and looks unprofessional (especially when time is of the essence). Also, bounce boards tend to be flimsy and frustrating to pack up when you're in a hurry.

31. Planning

Have a Plan B

Even if you don't start with a plan B, you might have to create one along the way. Not every wedding goes according to plan or on schedule. No matter how hard the bride tries, something will almost always go wrong and the photographer is often looked upon to fix the problem. Why? Because photographers see this every week and tend to know what works and what doesn't work.

The color version of the image to the right.

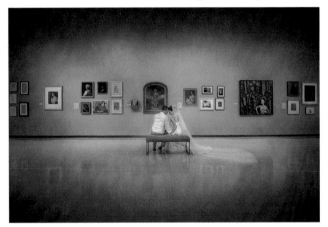

Another image made in the same area.

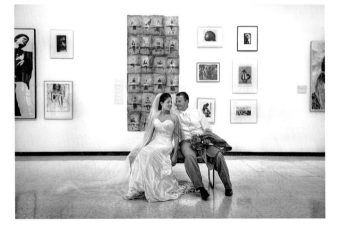

When Plan B Fails, Improvise!

This art museum was the bride and groom's plan B (in case of rain). They booked the location for wedding photos—but when we arrived, the woman who worked there said I wasn't allowed to shoot!

I took her aside and tried to work out the situation. Eventually, she agreed that we could work in the display area as long as the artwork

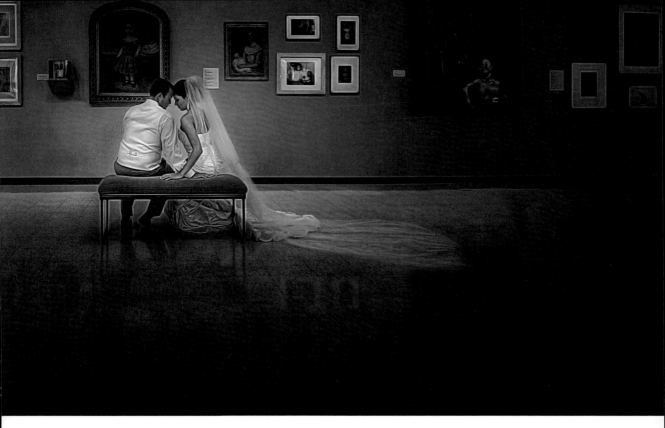

was not shown close up. Perfect! That's all I needed to hear.

I had the bride and groom sit on a bench that faced the art and took wide shots from afar. I showed one shot to the woman who worked there, demonstrating our trusting relationship. She gave us more leeway the more we worked.

It also helped that we left the bridal party in the limo so that the museum didn't have to deal with a bunch of partygoers. It's all about being honest and building trust. You never know when you might have to return to a location and need that employee's help in the future.

Dodging and Burning

If you have a busy shot and the bride and groom are getting lost, then dodging and burning will become powerful tools to help make your subjects stand out. Burn the entire image and then dodge your subjects until they pop out. Repeat the steps until you're happy with the results. However, beware of the potential for halos; use a smaller brush to reduce that risk.

32. Re-Creation

Popular Shots by Request

Once you create a beautiful shot, be ready for future brides to fall in love with it and request that they have the same shot for themselves. I, for one, prefer not to precisely reshoot popular images of my own (or anyone else's, for that matter). Instead, I say, "Okay, let's use the same idea but do something a little different—so that you have a unique photo of your own and not a copy of someone else's." In fact, we already saw one example of this in section 24.

Change It Up

There are countless ways you can meet the client's request to have a certain shot made and

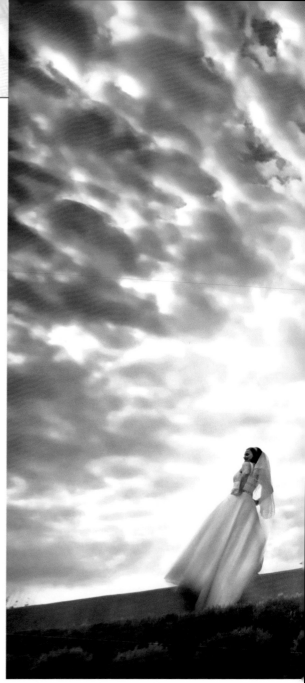

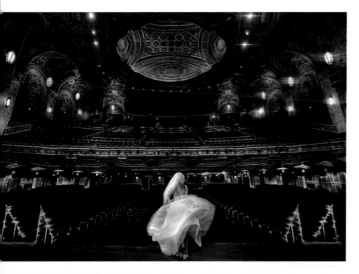

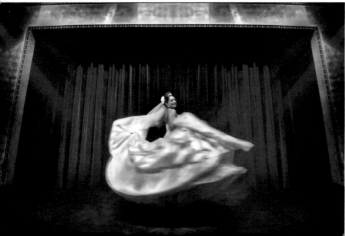

still deliver something that is uniquely their own. Challenge yourself to try these adaptations—and any others that come to your mind.

1. **Change the Location.** To the left, the brides are in similar compositions and poses, but a change in location makes each shot unique.

2. Change the Lighting. As we'll see in section 33, simply shooting at a different time of day is enough to create a different look. Or, add some light to change the look.

3. Change the Composition. Adjust the angle and/or height of your camera to give your new shot a different flavor.

4. Change the Posing. If the client loves a particular location (especially a very popular one in your area), give them a different look by really working the posing. Don't settle for how you "always" use the spot; find new ways for your bride and groom to interact with each other and the environment.

33. One Location, Two Looks

No Change of Venue

Location ceremonies and receptions are very popular among today's brides and grooms. However, when the entire event (from ceremony to reception) all takes place at one venue and you don't leave the property, you may be forced to shoot multiple images at the same location.

In this case, the bride got ready for the big day at this estate. Then we accompanied the couple and wedding party to a nearby church for the ceremony. Later, we all returned to this beautiful site for the reception.

Lighting Makes the Difference

Don't let a fear of repetition scare you off using the same location twice. The key is to return at various times of the day to take advantage of the different lighting as the angle of the sun changes. As the lighting changes, the scene will look completely different.

> "My first visit to this spot was when I took the bride out onto the balcony in the morning."

In this case, my first visit to this spot was when I took the bride out onto the balcony in the morning, just after she got dressed in her gown. This image is shown below. Positioning her carefully, I was able to shoot her portraits

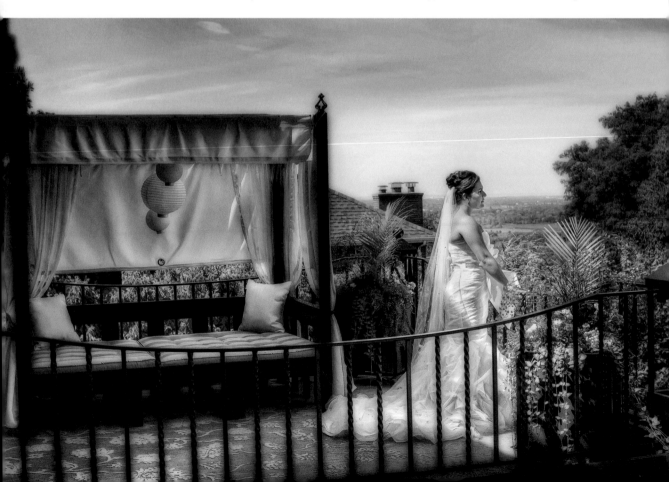

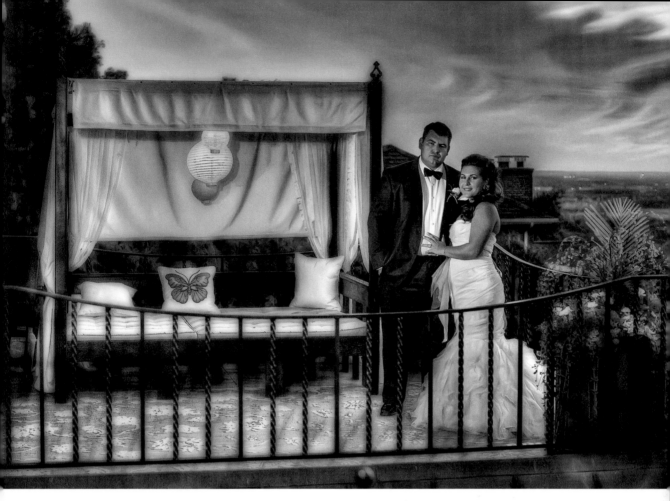

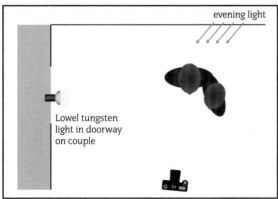

evening light

Lowel tungsten
light in doorway
on couple

using available light only, showing her pretty profile against the sky.

Later in the day, I returned to the same spot during magic hour, stealing the bride and groom away for a few minutes between the end of the cocktail hour and the start of the recep-

tion. On that visit, I took a photo of the now-married couple in nearly the same position as the bride had been. This image is shown above. The light was much lower now, so Danielle stood in the doorway to camera left, holding a tungsten Lowel light in position to create nice, warm lighting on the couple. This helped them stand out from the predominantly cooler tones in the background. The image also documented the bride's evening look, without her veil and with her hair let down.

Shoot with the Album in Mind

When it comes time to make their album, I can use these images as bookends. That way, the visual story will end right back where it started.

34. LED Portraits

LED *vs.* Flash

The images here show how convenient it is to work with an LED light—and the nice results you can achieve. Just turn it on, dim it down a bit, and watch the effect on your subject as you move the light into the right position. That's it—you're ready to take your shot. Each shot here took only about 10 seconds to create, and then we were on to the next look.

I could have created the same sequence of shots with a flash unit, but it definitely would have taken longer. With LED lighting, what you see is what you get; with flash, I would have needed to take a few extra test shots to get the lighting just right for each setup.

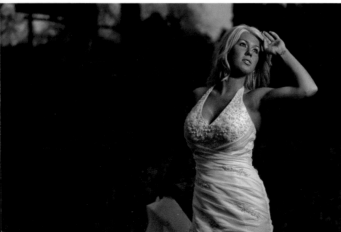

Time is not a luxury that we have on our side on a wedding day. Every second counts, so the faster and easier the equipment, the better! With the LED lighting, you basically have a portable window in your kit. What could be more simple or flattering?

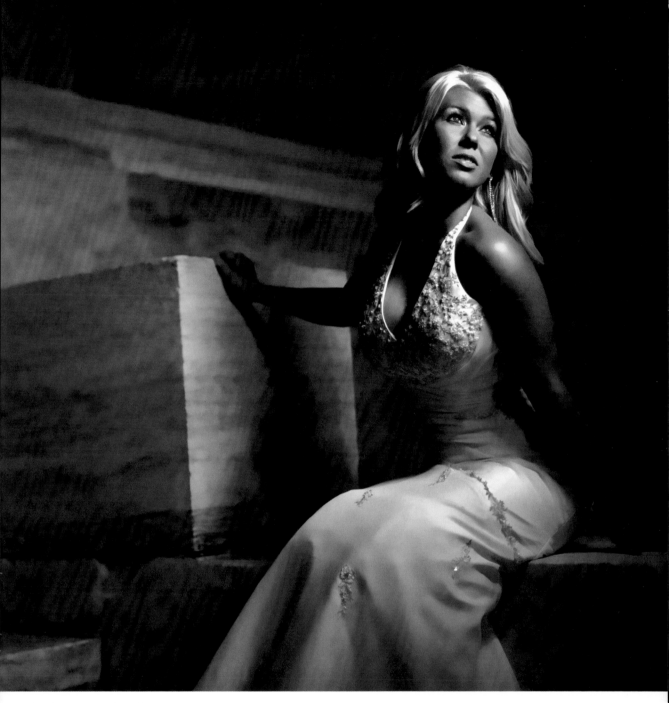

Better and Better

LED lights for photography are getting better and better. In 2012, I went to the WPPI convention in Las Vegas, NV, and learned about a new product called the Ice Light by Westcott. It looked like a light saber and it gave off great light that was accurately set to a daylight color balance. At the time, there weren't any accessories (like barn doors or gels), but Westcott promised they were coming soon. I took the plunge and purchased one (see section 25). I've been using it with great success ever since.

35. Dancing Poses

Hard Location, Soft Movement

If you're in a location that's dominated by architecture and strong, solid structures, a good way to give the location contrast is to introduce soft movement. Have the bride swing the train of her dress around to give the image some movement in contrast to the rigid building. This will make the bride stand out in the shot.

Alternately, you could have the bride and groom show you a few dance moves. This will also give the image some motion—along with a timeless pose.

If the bride and groom feel awkward dancing without any music playing, I ask them to practice the initial steps from their first dance. You could also tell the groom to swing his bride around and give her a twirl. It may help to reassure them that, even though it can feel strange doing this kind of pose, it will look good in their final images.

A Tricky Background Maneuver

Shooting straight down created a nice perspective on the couple, as well as the floor and the architectural beams. Unfortunately, there were some distractions at the top of the frame. To provide perfect symmetry, I created a mirror image of the bottom half of the photo and applied it to the top of the frame. I also mirrored the background horizontally using the same technique. Through careful masking, the couple remained untouched, but the background was rendered much cleaner and more appealing.

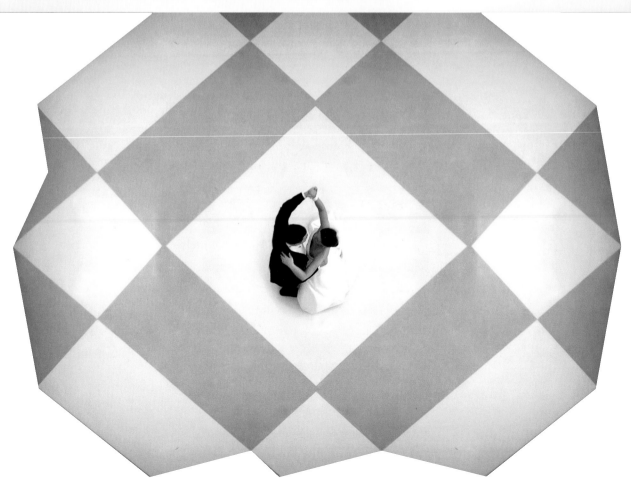

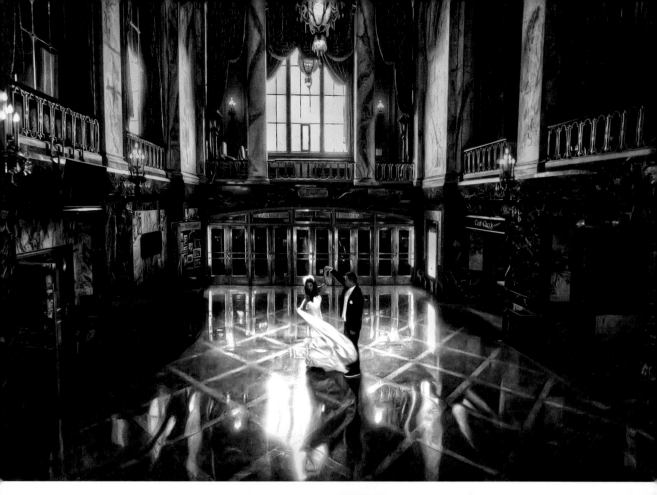

ABOVE AND RIGHT—The color (right) didn't add much to this scene. Converting to black & white (above) made the presentation more appealing.

I recommend doing these shots when the rest of the wedding party is away from the scene, so the bride and groom don't feel self-conscious about being watched.

Black & White

Converting to black & white is useful when the colors in the scene are either overwhelming or not adding anything to the feel of it. I sometimes use Nik Silver Efex Pro for these conversions, but more often I simply adjust the channel sliders in Photoshop's Black & White utility (Image > Adjustments > Black & White).

Try Another Angle

We're almost always shooting from "people" height, so when I get a chance to shoot from a different perspective, I always give it a try. Find a balcony or even just stand on a chair. For these dancing shots, a higher angle lets you see more of the twirl of the dress and adds variety to the image collection.

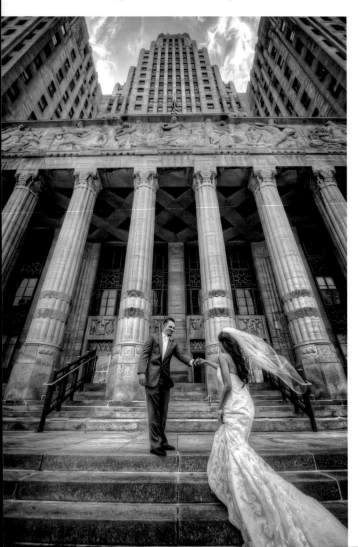

36. Posing

Natural Joy

A soft kiss on the hand is a timeless pose that I like to use with my couples. It's a romantic gesture that men don't often do anymore. To capture a genuine moment, I like to whisper to the groom to take his bride's hand and give it a kiss. The bride's face lights up every single time.

Demonstrating Poses

It's much quicker to demonstrate poses than to try to explain them; seeing the pose makes it easy to imitate. There's a side benefit, too: watching me strike a lovely pose I want the

bride to take is virtually guaranteed to loosen everyone up and make the shoot more fun. When I need to, I'll grab the groom and step right into the bride's position. Telling him, "I hope I'm not making you uncomfortable!" with a big smile on my face always gets a laugh.

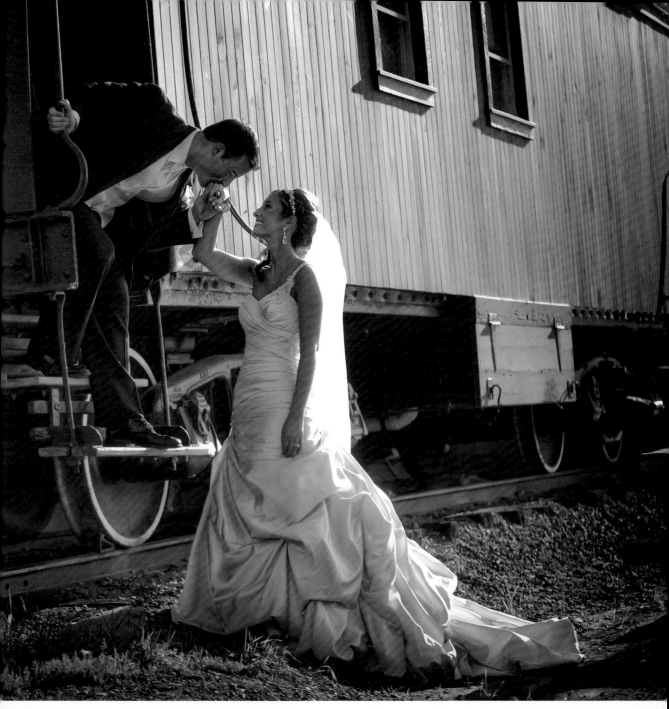

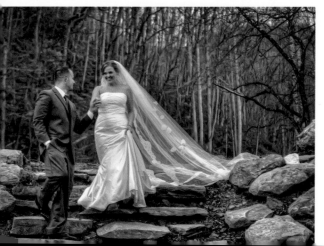

37. Destination Images

Dream Locations

Have you ever had a shot in mind that you thought would be impossible? One of mine was an aurora borealis shot. Unfortunately, it's not visible where I live, so I'd have to travel to a wedding in the right location and gamble on it actually appearing. Another dream (since I saw the location in a Chevy commercial!) was to photograph a bride in front of Yosemite's Half Dome. Sure, I could have Photoshopped these backgrounds in, but what fun is that?

A Compromise

When we got married, my wife wanted me to shoot our wedding. That seemed tough, so we agreed that I would photograph her later with some amazing backgrounds. That's how I ended up shooting *both* dream images.

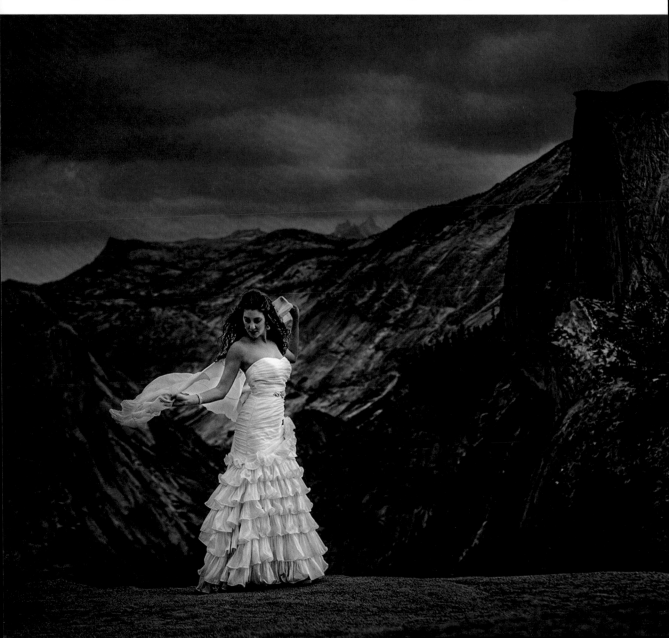

Aurora Borealis

Maine is the place where I proposed, so returning there for this shoot (right) was especially meaningful. Happily, we arrived to hear rumors of solar flare activity, meaning the aurora borealis might be visible. Atop Mount Battie, we waited for the light pollution from the town below to drop as the traffic slowed and businesses closed. Then, I shot 30-second exposures to capture the sky's colors. I had the flash fire at the end of the exposure to freeze Danielle in time. In postproduction, I worked with a single

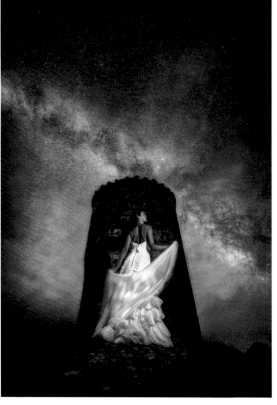

RAW file. None of the colors or stars were added; everything was captured in that one file.

Half Dome

We spent three days in Yosemite, and every day there was a clear blue sky—not the look I wanted. Finally, on our last day there, we awoke to a dark and gloomy morning. Perfect! We drove an hour up the mountain and Danielle got into her gown at the side of the road. I used a 200mm lens to pull in the background for the dramatic look seen to the left.

Not So Great

With the iPhone's lens (around 30mm), the relationship between the subject and scene was not impressive in this test shot I grabbed for my Instagram followers.

38. New York City

Grand Central Station

I always wanted to photograph a bride in Grand Central Station. I knew I wanted to capture a grand, wide-angle amazing shot . . . but somehow I forgot that (especially at midafternoon)

Get a Permit, But if You Don't . . .

It's always a good idea to get a permit to shoot, but sometimes (for whatever reason) it just doesn't happen. As I was prepping for my first wedding in New York City, I heard lots of horror stories about photographers running into trouble. I decided that if anyone stopped me, I'd just play dumb, show them my ID, and simply say, "I'm not from around here and I didn't know." As it happened, we saw many cops—but they never even looked our way.

there would be thousands of people inside! They are all on-the-go, living the New York Minute, and they don't care to stop because you're shooting a wedding. They'll walk in front of you and even stop and stare into your lens. The staircase seen in the image below was the safest spot to get the bride alone for a shot.

Anyone who has visited this landmark knows that, while the architecture is beautiful, the colors and lighting are kind of bland and dull. There are tungsten lights throughout the space, and the midday light through the windows isn't especially interesting. Using HDR brought out all of the colors for a more dramatic presentation. Again, the contrasting orange colors from the warm tungsten lights against the blue tones

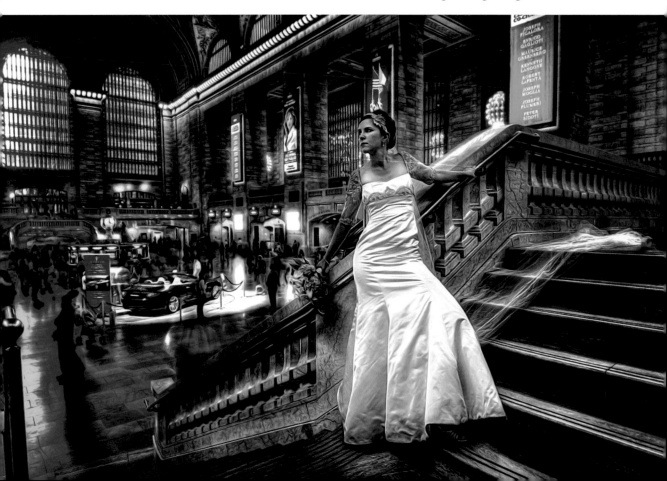

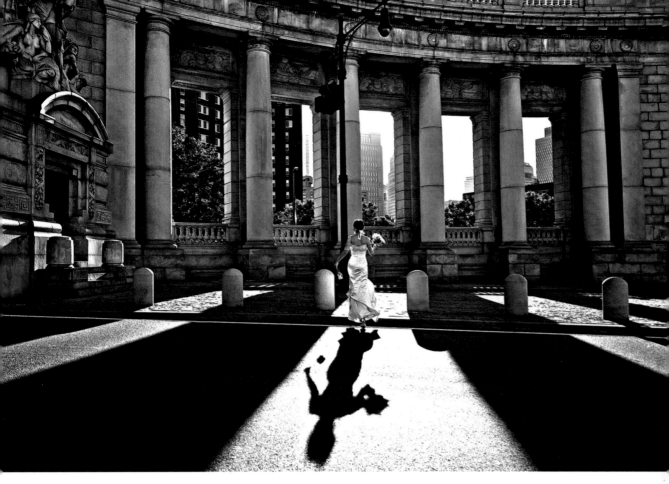

of the sunlit areas always looks beautiful to me—and I take advantage of it whenever I can.

Manhattan Bridge

Moments later, we were at the Manhattan Bridge (above). The side that was to my back had a lot of homeless people sleeping between the columns. Out of respect, we decided to take our happiness across the street.

This isn't exactly the easiest street to cross. The moment it cleared, we all started to run with the bride leading the way. When I saw her running in between the shadows of the columns and casting her own shadow in the street, I yelled for everyone else to stop (keeping them out of the frame) and quickly grabbed this shot.

Be Ready for the Unexpected

Always be ready to give commands and have the camera ready to shoot. When I'm not shooting in manual mode, I have the camera set to aperture priority—just in case of times like this when I need to pick up and shoot right away without thinking about or changing the camera settings.

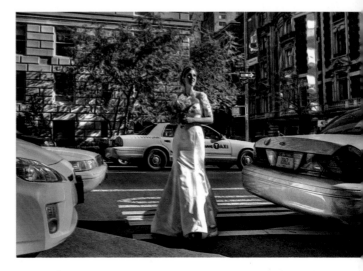

39. Autumn Splendor

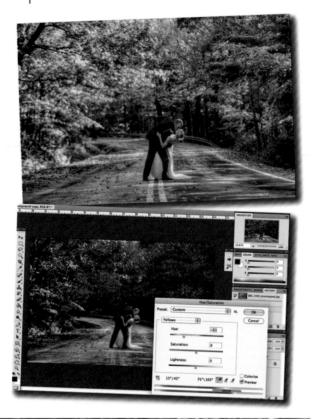

Giving Nature a Little Help

Autumn offers beautiful colors and textures for photographers (as seen on the facing page). Sometimes, however, nature doesn't give us exactly what we want—or maybe we just want to mix things up a bit. When that's the case, here's a simple trick you can use. The top-left image is a nice autumn shot, but the leaves were still green and yellow. I wanted something more dramatic, so I duplicated the background layer and went to Image > Adjustments > Hue/Saturation. I chose yellow as my target color and moved the hue slider over until everything became red. Some green was left over, so I switched to green as the target color and adjusted the hue slider again. I added a mask

TOP LEFT—The original capture. **BOTTOM LEFT**—Making the colors pop in Photoshop.

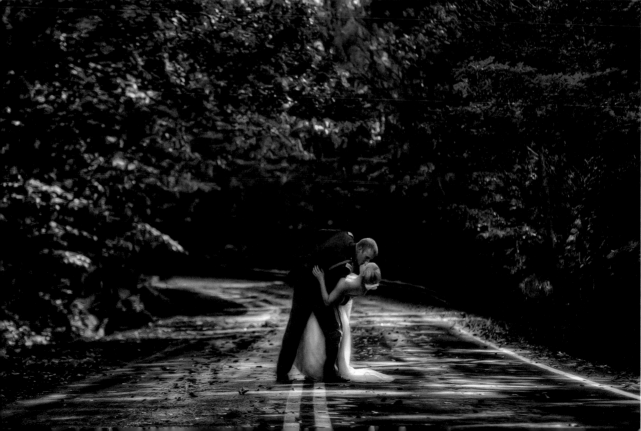

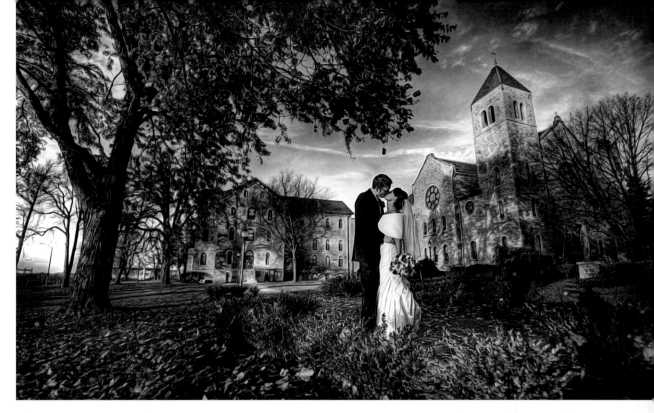

to make the yellow visible on the original road (from the underlying layer) and that's it. You now have exotic red leaves!

Leaves as Props

Work with what nature gives you. Sometimes it offers up great props, and that's especially true in the autumn. To create the image to the right, I enlisted a few members of the bridal party to grab some leaves and lined them up on either side of the bride. I said, "1, 2, 3—go!" and let the bride enjoy the moment as the leaves fell all around her.

Build on the Excitement

Shots like the one to the right are a lot of fun and get the bridal party excited about helping out, so we usually do a couple takes of each concept—even if we actually nailed the shot the first time. If you do nail it on the first try, then why not add the groom into the shot and give them more images to choose from? If you have something good going, then mix it up further and try some additional groupings.

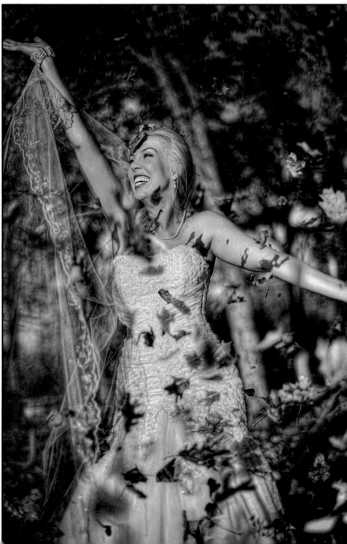

40. One Prop, Two Looks

A Natural Prop

On rainy or cold days, brides naturally bring props (like umbrellas) with them. You can use those props to your advantage and create several different looks with them.

> "It took about five minutes—so the bride and groom were back on the dance floor in no time."

Look for ways to use these props at different locations and with different lighting setups.

Having the bride and groom interact with the props will set your images apart from other wedding portraits.

In the image below, I had the bride and groom pose snuggly together under the umbrella to create a romantic image of the couple sheltering together from the storm. It's a sweet look that is perfectly suited to the whole idea of marriage.

Get Creative with Light

The image on the facing page was created on a night when it was raining cats and dogs—the rain actually stung when it hit you! The guests

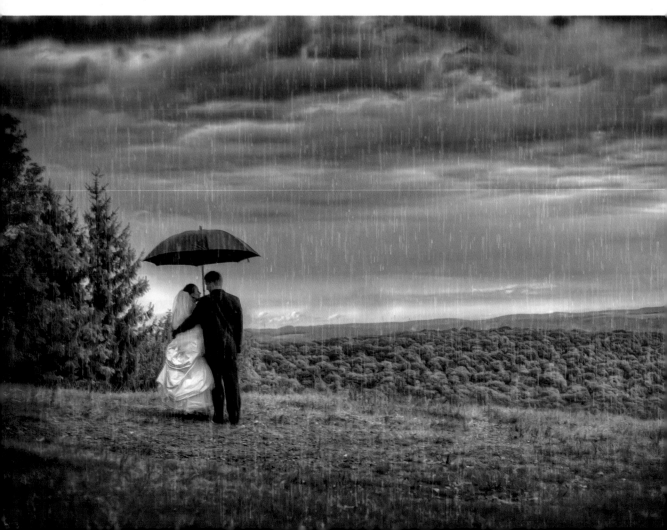

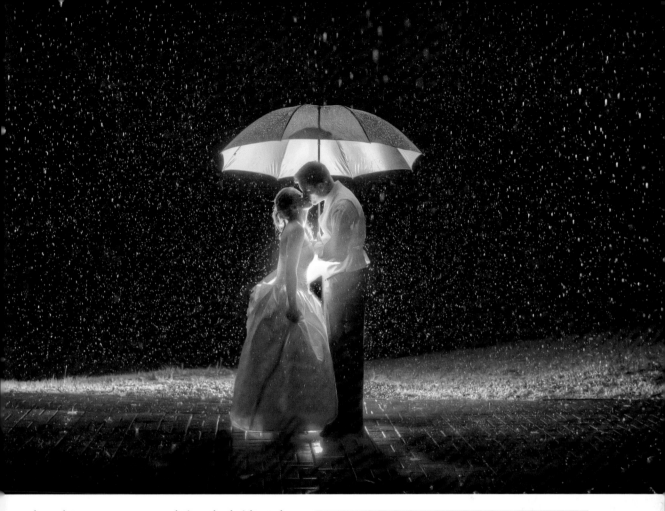

thought we were crazy to bring the bride and groom out in the pouring rain, but I had a feeling it would be worth it.

I adjusted my Nikon SB-900 to full power and set it to fire remotely when I clicked the shutter. My wife, Danielle (kneeling down behind the couple under her own umbrella) held the flash. She pointed it toward the bride and groom's umbrella so that the light would bounce off their umbrella and onto their fronts.

I gave everyone a warning when the light was going to go off so nobody got blinded by the full-power light. The light was so bright that it lit up the raindrops all around them—which really showed off how much it was raining and how large some of the droplets were.

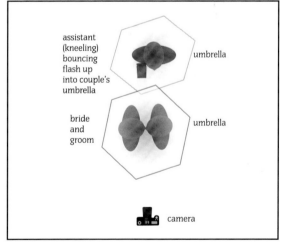

I took the shot, checked it on the camera, and that was it. This setup took about five minutes—so the bride and groom were back on the dance floor in no time.

41. Graffiti

Improvise and Create Contrast

In addition to demonstrating how well graffiti-covered walls can work for some couples' wedding photography, these images demonstrate two critical principles: the importance of being able to improvise when covering a wedding and the objective of building contrast for greater variety in your coverage.

Improvise. We chose this location in part because the bride was running late. It looks so good in their photos that, honestly, we might have chosen it anyway—but the fact that it was very close to the ceremony site was a deciding factor in this case.

Contrast. We like to shoot opposite seasons for wedding/engagement photos, just to give the couple some different looks. In this case, the couple had done their engagement session in Florida, so we gave them more of a gritty "New York" look in their wedding images to produce the same kind of visual contrast.

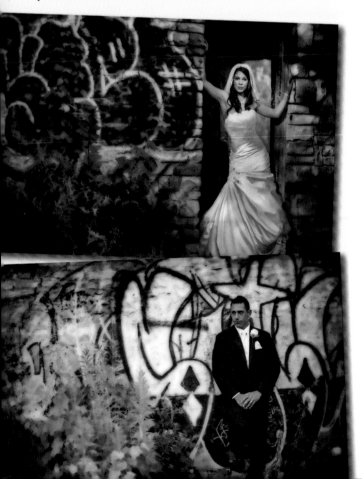

Cool—But Be Careful!

Graffiti makes a cool backdrop; it's colorful, vibrant, and makes images stand out. However, there is some street art that shouldn't be used. Take a careful look (or take a couple practice

shots) and study the art before you put the couple in front of the image. Sometimes, the graffiti can be too busy, so you'll have to make sure that your subjects don't get lost in the image. At one wedding I shot, I didn't really look at the art beforehand—and so I only noticed the profane words and images in the background when I got home from the shoot. I had to do a lot of work to remove the problem areas with Photoshop's Clone tool—and it was a serious headache.

BELOW—We shot this image alongside a bar, seconds before it started pouring. The couple was looking for artistic images to suit their Halloween theme, and this flaming wall-art shot tied in well.

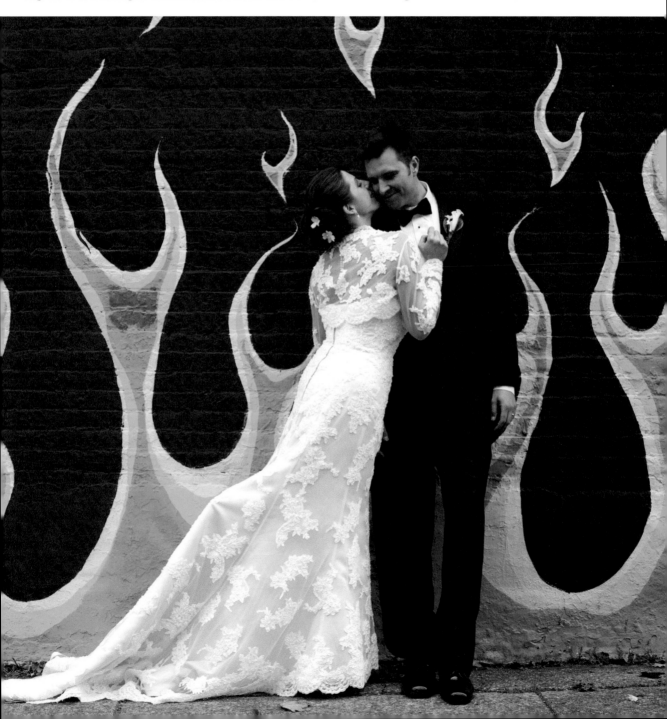

42. Winter Weddings

At the Bijou

In upstate New York, the wedding season slows down in November and December and is almost nonexistent until the spring months. Once in a while, however, we'll shoot a winter wedding.

The image on the facing page looks like it was taken late at night but it was about 4 or 5PM! In the summer months, at this time of day we'd still be fighting some harsh overhead sunlight. Therefore, winter weddings give us the opportunity to get some night shots that we normally wouldn't have the opportunity to create during the summer months. It's one of the nice contrasts between the seasons.

I had photographed at this location a handful of times but never used the restaurant as a backdrop because it's not lit up during the day. After dark, it gave us some really nice colors from the neon signs and the incandescent lighting inside.

Scout Indoors and Out

Be sure to scout all of your locations inside and out, whether it's a private residence, hotel, church, or reception hall. Wedding days are not only hectic for the bride and groom but also for you. Take control and call a time-out, then go walk around. A five-minute break will not ruin the day—especially when you find a location that makes the photos better.

Snow on Architecture

The image below was shot during a January wedding. Before the ceremony, I was outside taking exterior shots of the church and loved how the snow stuck to the building—as if it were a scene from Harry Potter! When the ceremony was over, we revisited the site.

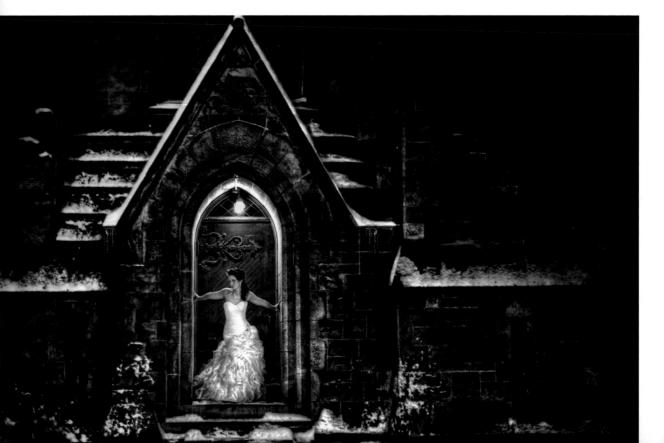

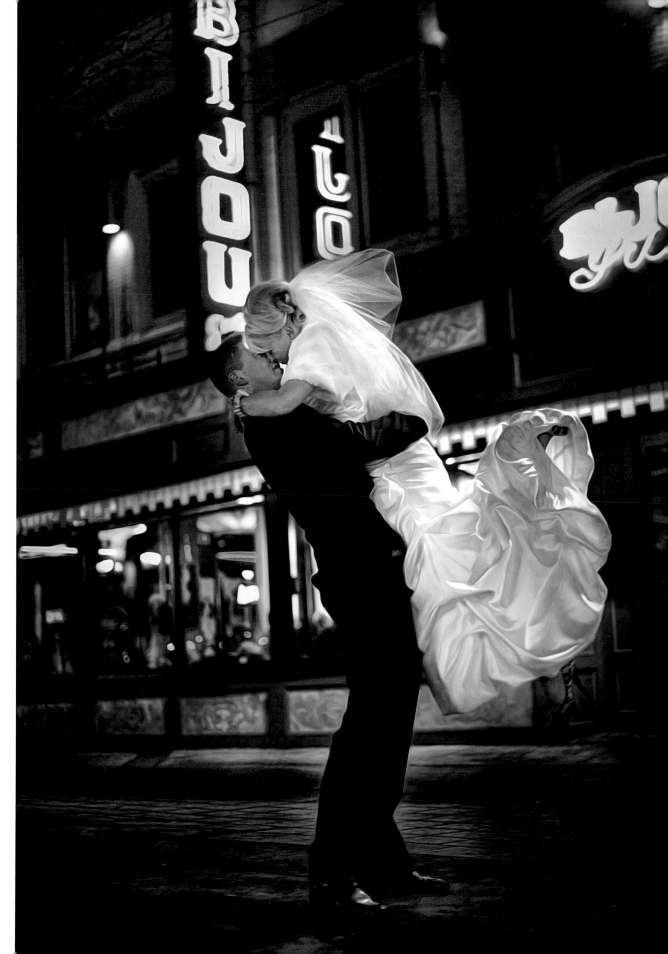

43. The Groom

Don't Neglect the Groom

The ladies have to share the spotlight for at least a few moments of the day and let the groom get some of your attention. (Without him, the day wouldn't be happening, right?)

Cool and Masculine

For the most part, wedding planning consists of dresses, flowers, decor, cakes, jewelry, etc.—not typically "masculine" things. Beyond the limo, music, and alcohol selections for the reception, the groom might not be all that involved in the decision-making process. So why not give him something to get excited about in the photography? Creating some fun, masculine shots during the day will help him feel cool and get more caught up in the excitement.

Because my pictures tend to be more dramatic and edgy than flowery or "light and airy," I find that the grooms are usually excited about the photography.

Location Selection

Finding the right location is one of the keys to creating cool portraits of the guys. Homes often

BELOW—At the home where the couple was getting ready, there was a game room above the garage. What's more masculine than a pool table? I included the bride, out of focus in the background, for balance in the composition. A Lowel tungsten light was positioned high to camera right, illuminating the groom. Shooting with a tungsten white-balance setting rendered the other ambient-lit parts of the room in cool blue tones.

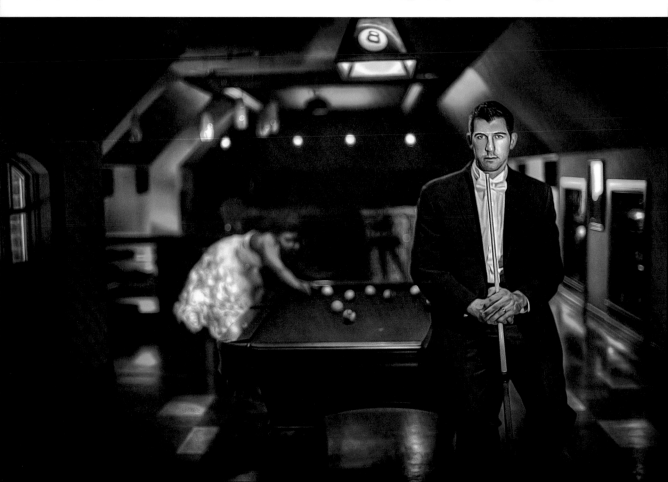

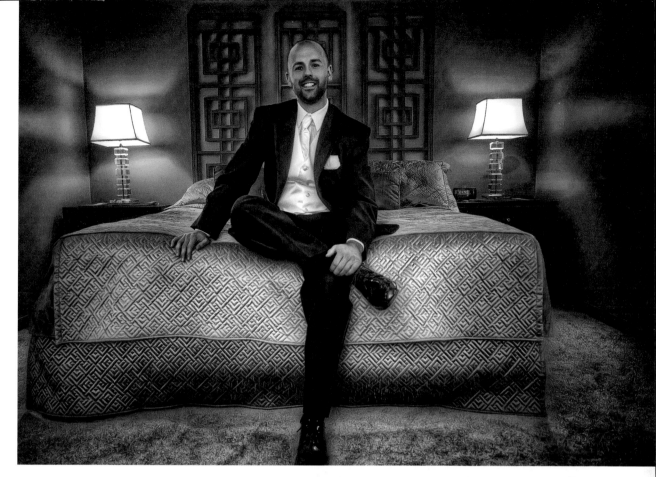

ABOVE—This image was shot with just the ambient light from a ceiling fan and the two lights behind him. To kick up the color, I used the technique described in section 39.

have a lot of "feminine" touches that don't make them suitable choices. If you find a game room or other "guy" space, take advantage of it. In hotels or other commercial spaces, look for clean lines and either vibrant colors or cool neutrals.

Posing

When posing guys, I want them to look and feel natural. I ask them, "Are you more an arms-crossed kind of guy? Hands in pockets?" Guys tend to be most comfortable leaning or sitting, so I rarely put grooms in freestanding poses—as you can see in the images on these pages.

RIGHT—Window light from camera left illuminated this groom, posed leaning on a table with an abstract painting in the background.

44. Sunset

Great Lighting—At Last!

Ahh . . . finally! The light you've been waiting all day for has arrived!

In the perfect world, every wedding would take place after 5PM, but this world is far from perfect. At most weddings, the major events take place in the afternoon and under the least appealing or flattering lighting possible. Who loves to shoot at 12–4PM? Certainly not me. But, hey, as professional photographers we have to work with what we're dealt and get creative.

So when that sun finally sets, I hope that every photographer in the world is getting out there to take advantage of it. It will be the best light of the day.

Two Exceptions

In general, there are only two circumstances under which I would take a pass on sunset lighting. If there is absolutely no usable outdoor background at the reception venue or if the sky is very overcast (so the lighting wouldn't be great), it might not be worth interrupting your clients' enjoyment of their reception. Otherwise, get out there and make some great images for the bride and groom!

BELOW—With the couple posed in the gazebo late in the afternoon, a speedlight was positioned behind them. This was pointed up at the roof of the structure to light up the couple and the whole area around them.

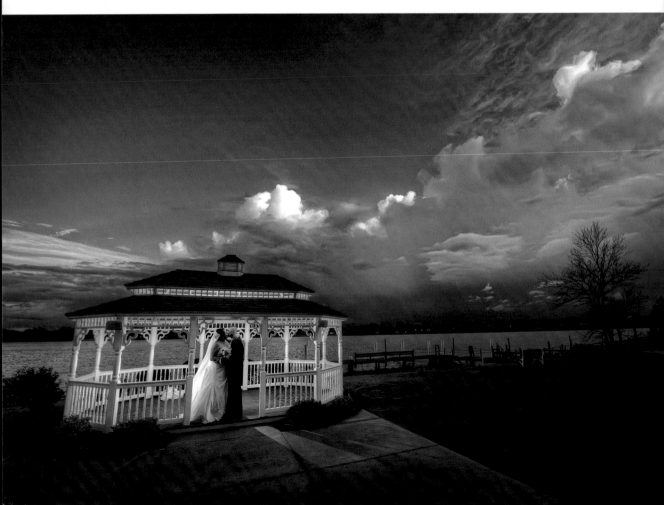

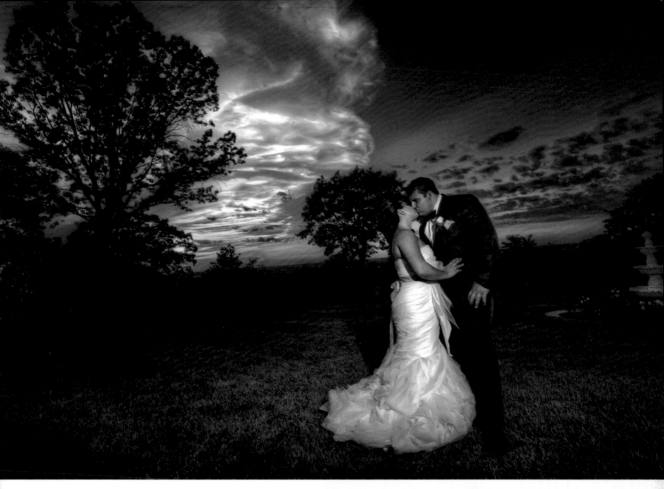

ABOVE AND RIGHT—A speedlight (with diffuser cap) to camera right was held by Danielle to light the couple above. Available light only was used in the image to the right. In both images dodging/burning was used judiciously to boost the color and contrast in the sky.

Take a Quick Break

If sunset occurs when the speeches or introductions are about to happen, I contact the wedding coordinator or DJ and ask them to stall for a few minutes. I explain that we have an amazing photo opportunity happening outside right now and I don't want the couple to miss it.

Trust me, clients who care about their photos will value your judgment and ask for a delay themselves. (And who doesn't listen to

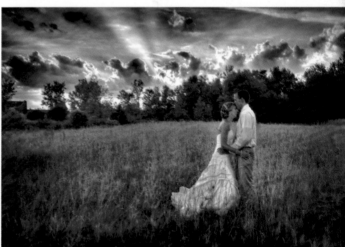

the bride on her wedding day?) I always tell my brides and grooms, "If you see me excited about something, then follow me—and we'll make it happen by any means necessary!"

45. Backlighting

Depth and Separation

No matter what photography lighting book or manual you read, you can be sure that it will discuss the importance of backlighting. Whether the light is from the sun, a window, or a flash, backlighting is important because it visually separates your subjects from the background. It also improves the sense of depth, making a two-dimensional image look more like the three-dimensional world.

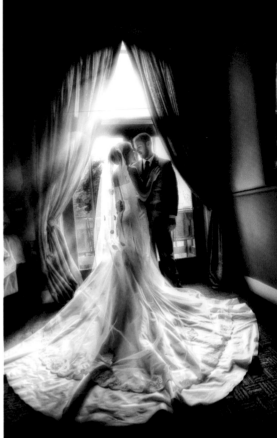

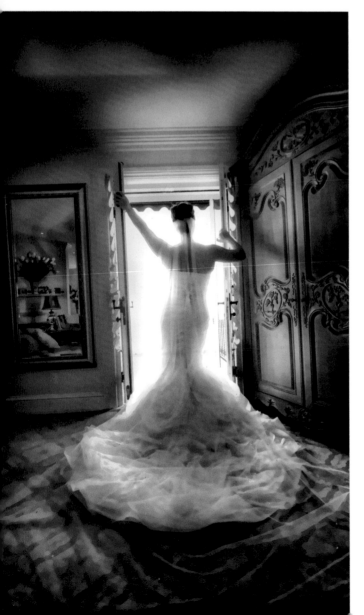

Adding Light (Or Not)

When using backlighting, you might choose to lighten up the shadow side of your subjects with some fill light to preserve detail. Alternately, you could add a main light and use the backlight for rim or accent lighting. Another option is to add no light at all, so the backlight produces a nice silhouette.

Is it necessary in every single image you take? Of course not, especially at a wedding. But if you want to spice things up, then throw some backlight on your subjects.

Black & White
(With a Hint of Color)

As noted in section 35, I often like the look of black & white for architectural locations—especially where the color isn't adding a lot to the feel of the image.

To create this look, I began by duplicating the background layer. Working on the duplicate layer, I applied a black & white conversion by going to Image > Adjustments > Black & White. At the top of the dialog box that appears, you can select from a range of preset adjustments. More often, however, you'll want to make custom adjustments to the color sliders below. In this case, you can see I tweaked every channel to arrive at the desired result—so be prepared to do a bit of experimentation.

To soften the look for the presentation seen below, I reduced the opacity of the black & white layer to 81 percent, allowing a bit of the original image's color to show through.

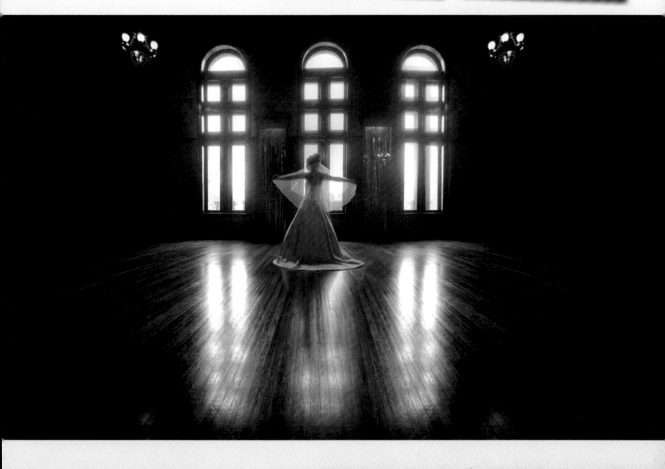

46. Unplanned Subjects

Distractions or Assets

Sometimes, pedestrians get in the way of creating the shot you had in mind. Other times, you can use their presence to your advantage and create something unexpected. It's one of the ways we improvise as professional image makers.

Whenever someone's presence in the frame interferes with my shot, I kindly ask them if they can move for a few moments. However, if they can enhance the shot, then I let them continue with whatever they're doing (and I try not to make it obvious that I'm including them

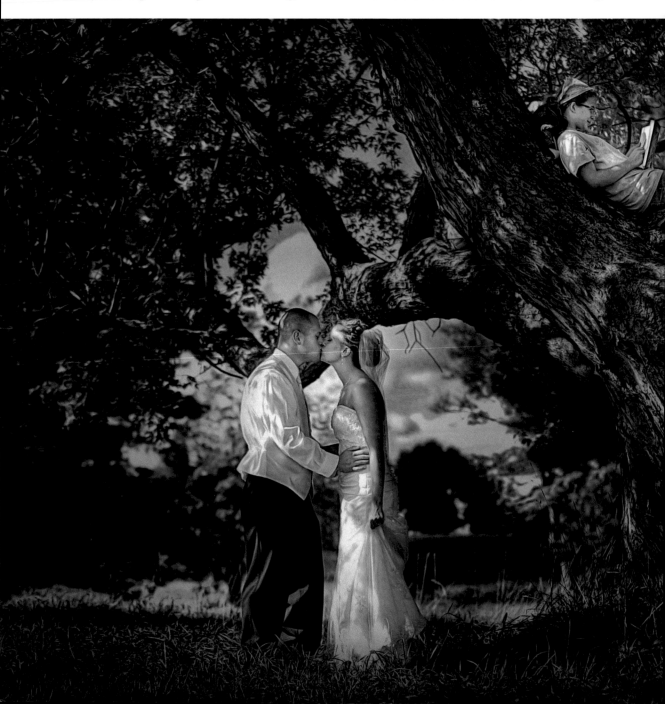

in my photo). After I get the shot, I tell them that they made it into the shot and show them the image.

When most people see a bride, they want to stop and stay hello or offer their congratulations. And if you want them to be included in a shot, most of them are overjoyed to be a part of the big day. On the off chance they don't want to be bothered, we politely continue on.

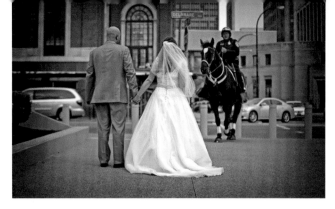

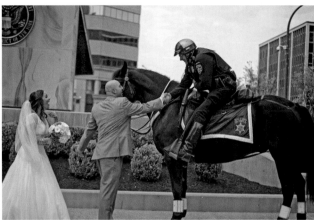

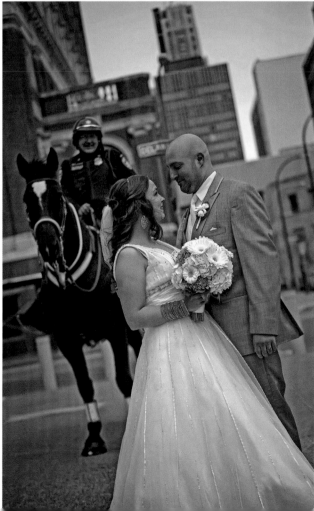

47. Reflections

From Ordinary to Extraordinary

Want a unique spin on a normal portrait? Look for reflections. Whether it be a mirror, window, television, shiny tabletop, or even a puddle, reflective surfaces are all around us—so use them to your advantage. It will help turn the ordinary into the extraordinary. (See section 28 for another example.)

Camera Position

To get a reflection of the subject without a reflection of yourself, stand close to the mirrored surface. Tweak the camera and subject positions for a nice view of the background and subject.

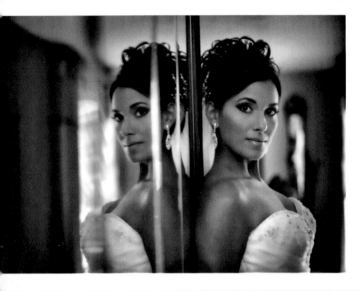

LEFT AND BELOW—Mirrors and windows both provide good reflections.

FACING PAGE—I shot this through an interior door with beveled glass. A Lowel light held behind the groom created rim lighting.

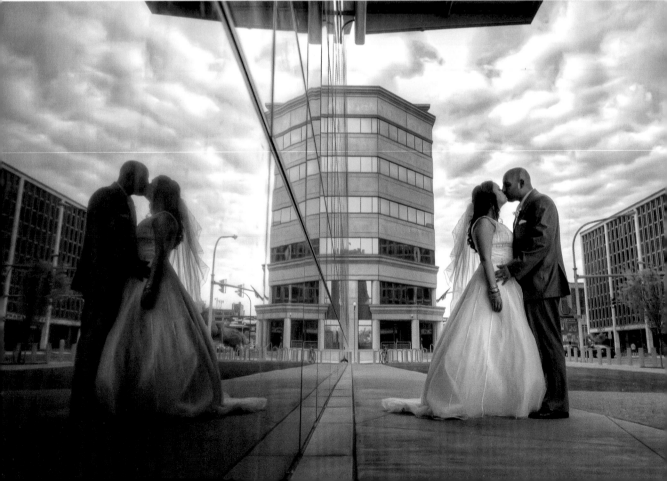

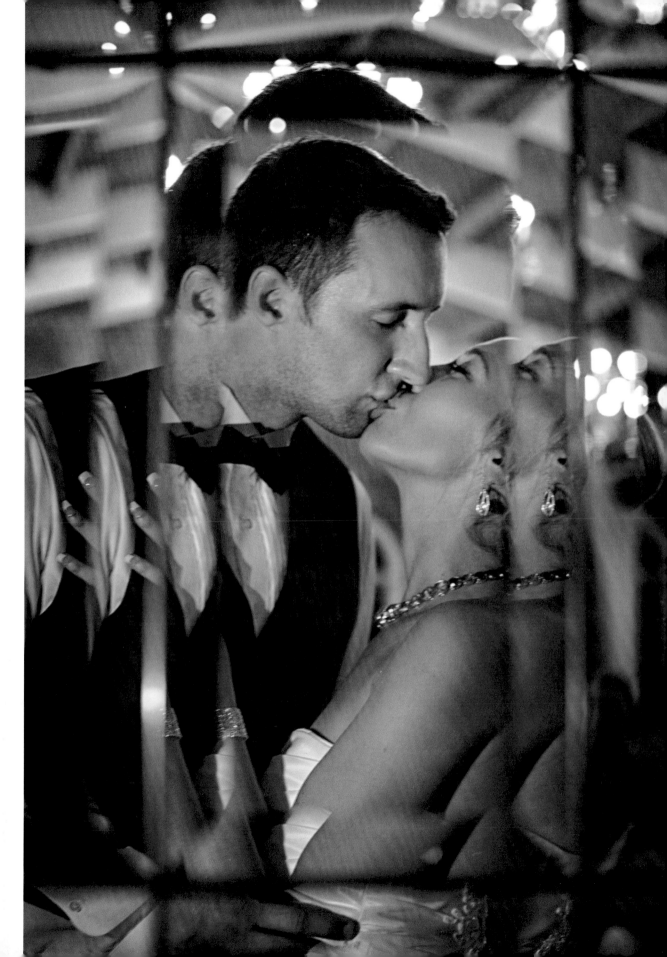

48. Short on Time? Improvise!

Don't Panic!

Don't have enough time between the ceremony and the reception to visit all of the locations where you had planned to shoot? Don't freak out—it happens to all of us.

Have a Plan

Sometimes, I've done all the portraits at one location with as few as ten minutes to shoot. To do this, you need an organized plan of action. You need to work quickly and keep everyone on task, moving toward the common goal of getting to the reception on time.

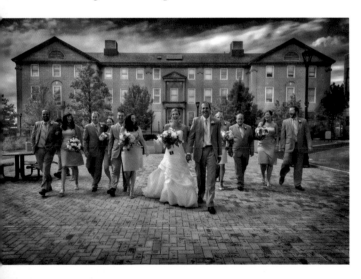

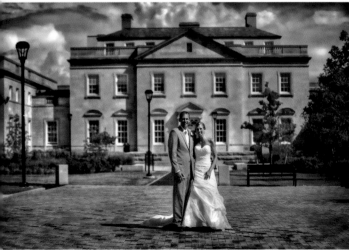

Group Portraits

For this wedding, I started out with the entire bridal party. Then, I separated the men and the women for a ladies-only group shot. This was followed by one-on-one shots of each bridesmaid with the bride. While I shot these images,

the groom was getting ready to pose for the same sequence of group and one-on-one images with his groomsmen. The entire bridal party was done in two minutes!

The Bride and Groom

Once the group images were wrapped up, I sent the bridesmaids and groomsmen back to the limousine.

Now, I had the bride and groom alone for five minutes and got some nice images of them just interacting on their own.

I had the bride step aside so I could photograph the groom alone, then the bride stepped in and the groom stepped out so I could do solo portraits of her. Done!

In ten minutes, we had all the important images—and they got to their reception on time!

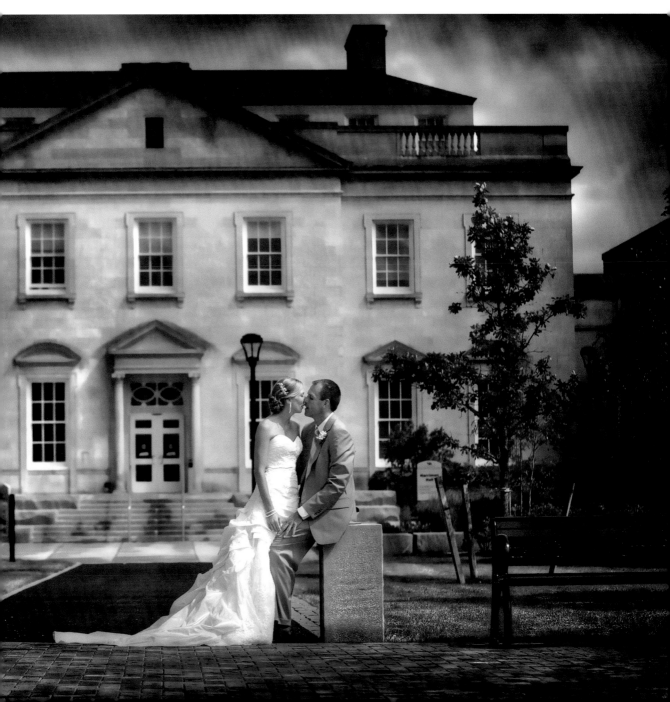

49. Busy Locations at Night

One of my favorite things to do is shoot at night—even in busy locations. Here are three different approaches to consider. I highly suggest practicing them with your friends before attempting them with clients.

Approach 1: Subject Exposure Plus a Long Background Exposure

From a tripod, get your shot of the subjects. If there are a lot of people walking around, you'll

> "With a long exposure time, any people who walk through your scene will be invisible."

then take your second shot as a long exposure—maintaining the same framing as you used to create the first shot, so it will look the same as the subject image. With a sufficiently long exposure time, any people who walk through your scene will be invisible.

In postproduction, place the subject image on a layer above the background image and add a black layer mask. With the foreground color set to white, paint on the mask to make the subjects visible. If anything was blown out from the long exposure on the background, then you can mask in those parts, as well (again, by painting with white on the black mask).

Approach 2: Subject Exposure Plus Multiple Background Exposures

Another way of doing this is to take the shot of your subjects in one image. Then, take a look at the preview image and note where unwanted people are standing in the scene. When the people move away, take another shot—and keep doing so until you have a clear shot of each sec-

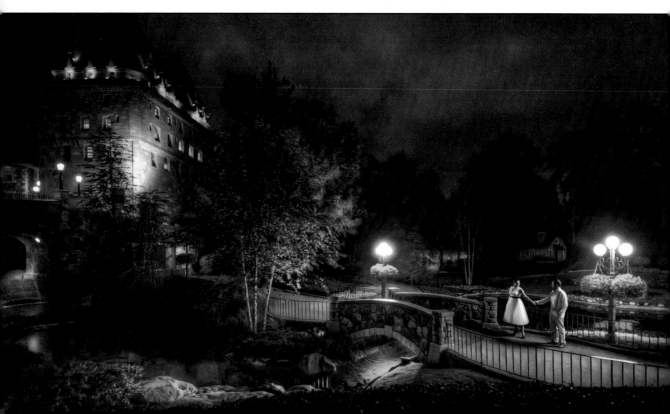

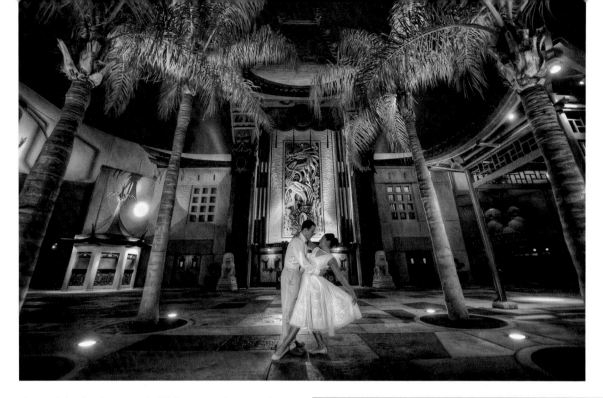

tion of the background. This may take anywhere from two to ten shots.

In postproduction, you can mask the images together as described above. Alternately, you can open all the background images in Photoshop by going to File > Scripts > Statistics. Choose "median" and select the files. Photoshop finds what is different in the photos and simply removes it. Then, mask in your subjects.

Approach 3: A Single Exposure

You can also take a long exposure of the whole scene with your clients in the image—but your results will vary depending on the ambient light.

To do this, have the subjects stand very still. Start the long exposure, knowing that anyone who walks through the frame will be invisible, then have your flash go off at the end of the exposure. (*Note:* Set your camera to rear-curtain sync to make the flash go off at the *end* of the exposure, not at the beginning.)

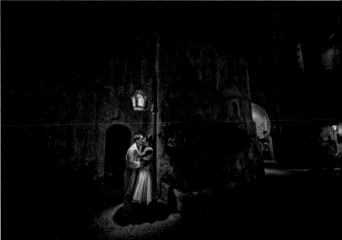

If there's a lot of ambient light, then your subject may seem a bit blurred—but the effect could look cool. Also, if your flash goes off brightly and there are people nearby, the flash might illuminate the bystanders and make them visible in your shot. Is that a problem? It all depends on the look you're going for.

Practice with nighttime photography. You just might surprise yourself—and your clients!

50. Girls Just Want to Have Fun

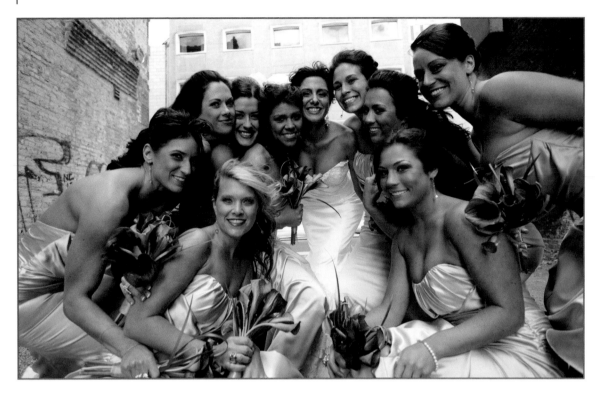

One-on-One Portraits

It's true—the ladies do want to have fun on the wedding day! So do fun things with them. To get them loosened up, I like to start by having each girl get her photo taken with the bride. That gets everyone into picture-taking mode.

Group Shots

Next, I group them together. Remind them that they're all friends and have them get as

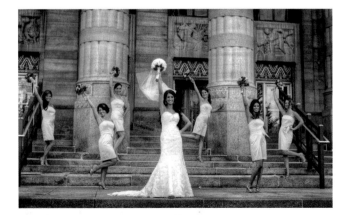

close as they can (*Shot!*). "Big smiles!" (*Shot!*) "Everyone look at each other!" (*Shot!*) "Have a laugh!" (*Shot!*) "Show off those shoes!" (*Shot!*) "Point those flowers at me!" (*Shot!*) "Now, I want you to walk away from me. When I say 'Stop!' strike a pose and look back at me!" (*Shot!*) "Okay, now walk back toward me—and make sure that the bride is front and center." (*Shot!*) "You can all look in different directions or you can look at me." (*Shot!*) "When I say stop, strike a pose that suits your personality!" (*Shot!*) "Now, all together, hug each other with big smiles." (*Shot!*)

That's how I photograph the ladies—nice and quick, without leaving them time to think too much or try too hard.

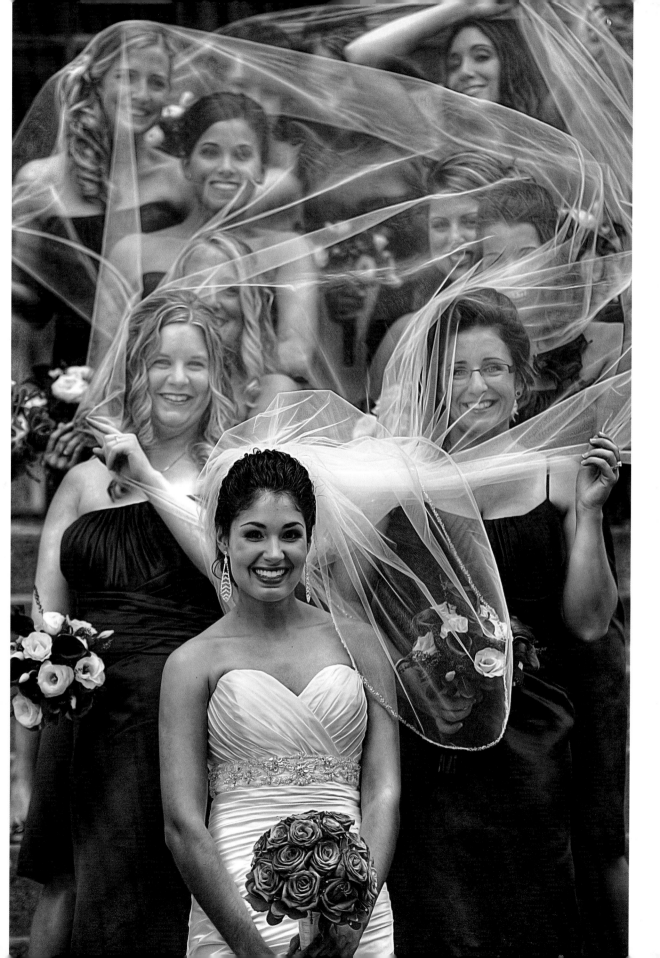

51. Veil as a Prop

We've looked at several examples of how the veil can become a great compositional element when you're shooting on windy days. (See sections 12, 17, and 20–22.) There are other ways to use the veil in group shots.

Benefits

If the bride's veil is long enough, it can be used as a beautiful prop for the wedding party to interact with. Using it this way has some nice benefits. First, posing the hands in a way that

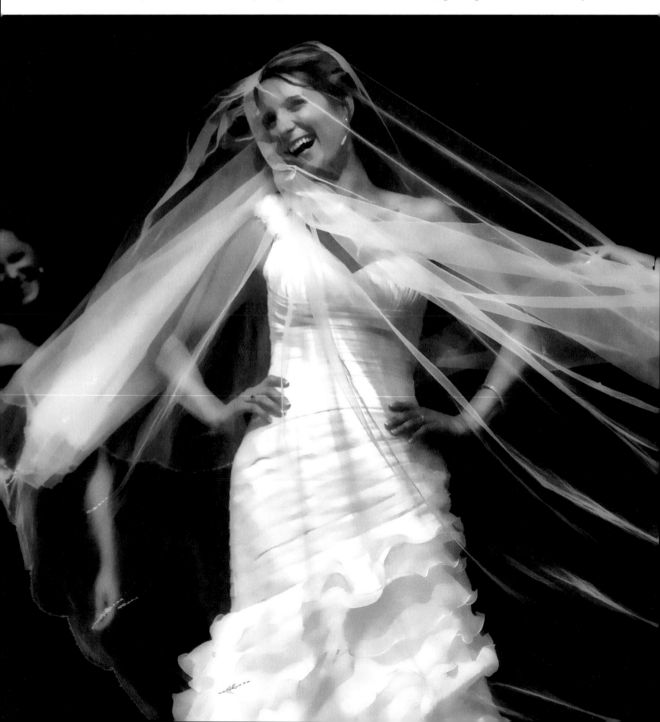

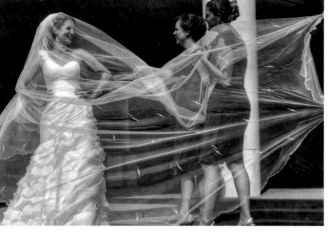

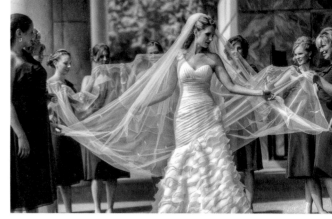

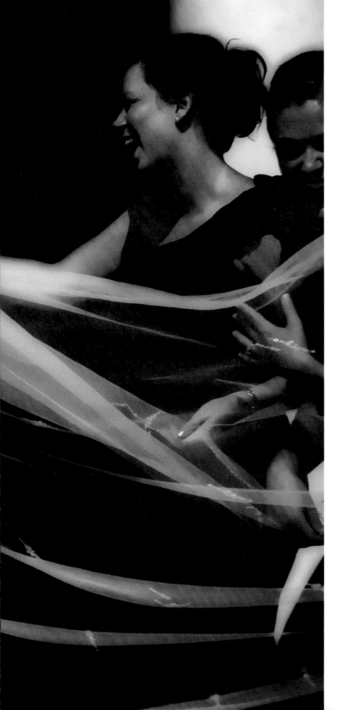

looks natural can be challenging in group portraits, but asking the ladies to hold the veil gives everyone something to do with their hands. Second, this type of pose gives

"Having everyone holding the veil visually links all of the subjects."

everyone something to focus on, resulting in more natural expressions. Finally, in terms of composition, having everyone holding the veil visually links all of the subjects for a unified look. (See section 50 for another veil example where this is especially apparent.)

Posing

Generally, we start these setups with the bridesmaids gathered around the bride (make sure their faces are all visible). Then, have the girls pick up the veil (as in the top-right photo), leaving the bride's face in full view. For a look at the veiled bride, ask the ladies to wrap the veil around the bride (as in the left and top-left photos).

Have Fun with It!

Keep the energy up and make sure everyone is having fun—you want to see lots of smiles and laughter in these images.

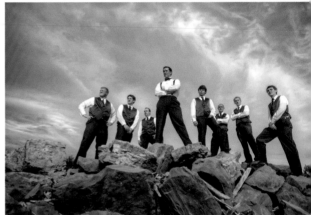

52. The Groom and Groomsmen

The Ladies with the Groom

While the ladies are still fresh from the fun of their girls-only images, I send the bride away and call in the groom to begin his part of the photography. I'll start by inviting the ladies to show the groom some love and take that shot (as seen to the left). I encourage them to get nice and close, then take a few more shots.

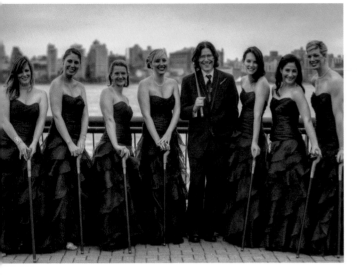

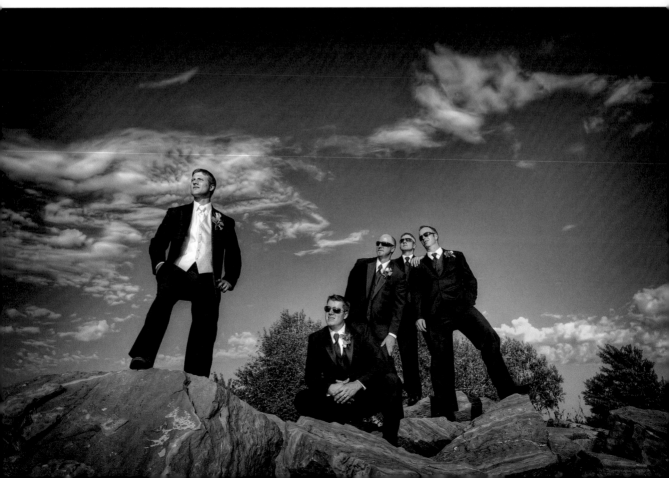

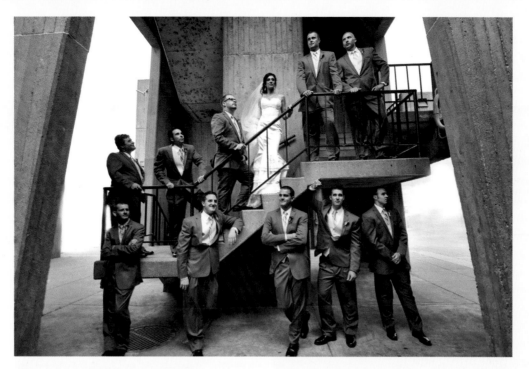

The Guys with the Bride

For my final shots with the guys, I send out the groom and call in the bride. I often like to pose the guys like security agents, protecting the bride. This shot is a nice complement to the first shot of the groom/groomsmen, where I have the groom with all the ladies from the wedding party.

The Guys on Their Own

Next, it's time to focus on the guys. As noted in section 43, I want the guys' shots to be cool and masculine. That means choosing settings that look somewhat rugged (here, rock outcroppings and rigid architecture do the job) and poses with a "tough guy" feel. Standing poses with the feet a bit apart and the arms crossed or tucked into pockets work well. A lower camera angle also adds to the drama, making the men look more assertive and powerful. Unlike the bride, the groom is usually dressed pretty much like his attendants, so be sure to keep the emphasis on him through posing and composition.

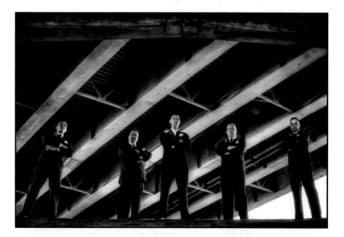

Add Some Motion

For an action shot with the guys, try a *Reservoir Dogs*–style pose with the men in a line, walking toward the camera.

53. Reception: The Basics

Reception images won't be your flashiest work, but they're important to clients. They are mementos of some of the most iconic and sentimental events of the day, and reminders of a great party with their closest friends and family. The following are some key elements.

Detail Shots and Networking

We arrive about thirty minutes before the cocktail hour to get detail shots of the room before the guests start putting their coats down or meandering in the background. With the room basically empty, we can also set lights without tripping people. This is the time to shoot the place settings, floral arrangements, and the cake. (*Tip:* Chandeliers in the background create a nice *bokeh* for these, as in the top-left image.)

It's also a good time to network with the vendors who are finishing their setup. We make sure to connect with the DJ, who will know the sequence of events for the rest of the night. We want everyone to be on the same page and know what the next few hours will hold.

A Little Break

At the venue, there may be a receiving line or cocktail hour. At this point, we give the couple their freedom for about an hour. We have a drink, shoot candids, and take a little breather before diving into the evening's activities.

Introduction Shots

When it's time for the bride and groom to be officially introduced and make their big

Lighting

At the reception, we do a lot with a hot-shoe mounted flash, bounced off the ceiling and walls. We used to choose a tungsten Lowel light for off-camera lighting, but now we pretty much rely on the Ice Light (see sections 25 and 34) or, in some cases, a second flash unit.

entrance, we cover it from two perspectives. Danielle shoots wide-angle, while I shoot close. Couples often have dances choreographed for this moment, so we want ample coverage.

Speeches/Toasts

For the speeches and toasts, we work from opposite angles to the head table. I photograph the speaker, while Danielle shoots the couple's reactions (see section 23 for an example).

Cake Cutting

We continue our two-angle approach with the cake cutting. I shoot the moment wide-angle using the Ice Light, while Danielle works with a longer lens for views of their hands on the knife and close shots of them feeding each other.

Bouquet Toss

Bouquet tosses are less common today than in past decades, but if the couple opts to include one, I cover it wide from a high angle (usually standing on a chair) while Danielle gets tighter shots of the girl who catches the bouquet.

General Images

Throughout the night, we also shoot general images of the guests partying, just to show who was there and that everyone had a good time. As noted in section 55, we're also on the lookout for funny or emotional moments.

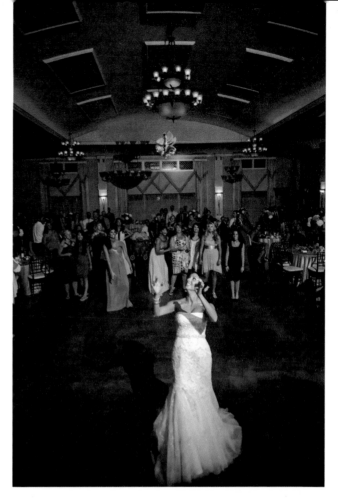

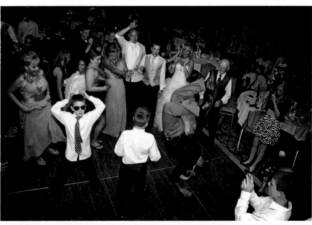

54. First Dance

Evaluate the Dance Area

Before the bride and groom start their first dance, I look over the dance floor and see what angles I will cover and what angles my assistant will cover. I get our lights set up and also see what ambient lighting is available.

Give Some Directions

If the room gives us good lighting, I will want to use that light at some point during their first dance. If they have a choreographed dance, I will follow their lead and be sure to capture them in the spot I need them to be.

If, however, they don't have a coordinated dance (as was the case with the image below) and just slow dance in one spot, then I'll tell them exactly where I need them to be. Simply ask them to dance in the middle of the floor, or in the spotlight, or underneath the chandelier. This prevents the frustration of hoping that they will step into the desired light.

Once they start dancing where you need them to be, take your grand shot. Then, move in for the kill and get those close-ups. Or you can take the opposite approach and get those special close-ups first, then work your way to the grand wide-angle shot, showing off the room and their guests watching.

Attention to Detail

During their first dance, the couple will be excited and probably somewhat nervous—but they will definitely *not* be paying any attention to where they should dance for the lighting to look great. They have hired you to do that job, so be observant of your surroundings and where the best light is.

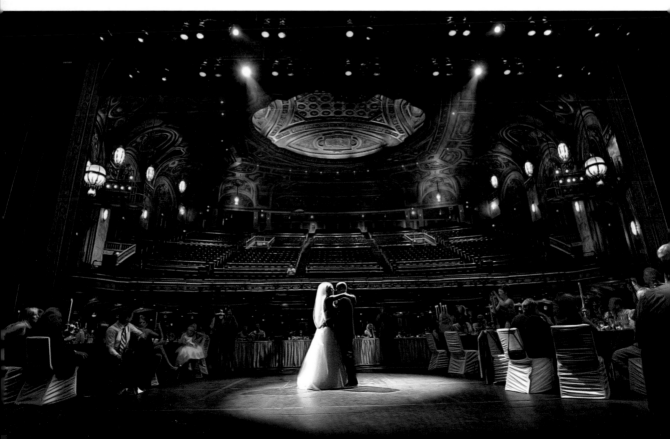

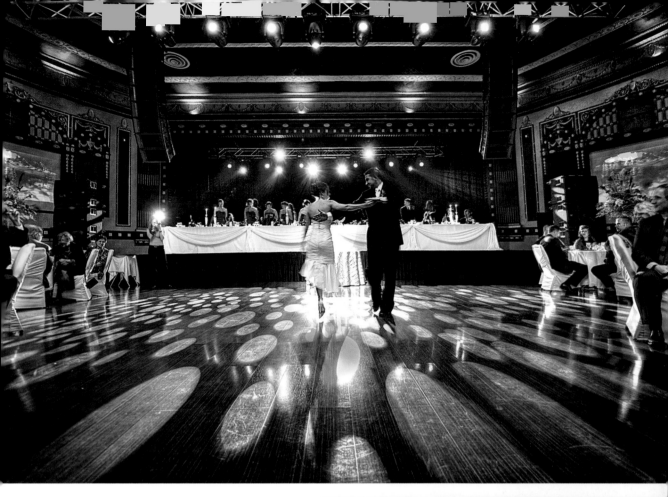

Choreography

The image above shows a first dance that was choreographed. The couple was in the center of the dance floor for only a short period of time—but I was ready to get my wide-angle shot.

As I was sitting down with my wide-angle lens, my wife Danielle was getting the close-ups that I was missing. (In fact, she is visible at the back left of the image—but this doesn't bother me, because she's very small in the frame and can pass for a guest taking photos.)

When covering this kind of action, teamwork is important. My wife and I know each other so well that when I get in a certain position she knows that I'm shooting wide and she'll go in for the kill. If she sees the monster 200mm

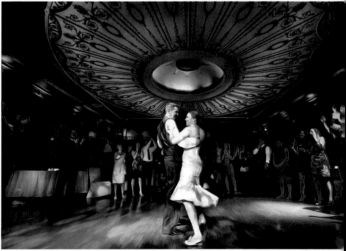

come out, then she knows that she can go wide if she wants. In this case, I got lucky and snapped the shot at the same time she did, so I captured her flash as it lit up.

55. More Special Moments

Prepare for Surprises

One of the things I love about photographing weddings is that I never quite know what's going to happen—and I have the privilege of capturing it all. Once I get the basics done, I keep my eyes open. I never stop looking around the room, watching for any displays of emotions or surprises. I also keep my camera ready to grab them.

Orchestrate an Encounter

If you see an opportunity to set up a special image for the couple, jump on it!

The bride and groom shown on the facing page had a Disney-themed wedding. While they were eating their dinner, I surprised them by asking the staff to set up a table just like the famously romantic spaghetti scene from the Disney movie *Lady and the Tramp*.

When I called the bride and groom over to the table, their faces absolutely lit up with excitement. They knew *exactly* what they needed to do next for the perfect moment. It's the small things that go a long way to make someone's day that much more special.

We lit the shot with a Lowel light held to camera left. To complete the shot, during postproduction, I brought in a "hidden Mickey" shape in the background; see section 16 for another way this motif was incorporated to build on the couple's theme.

LEFT—Keep your eyes open and your camera ready to shoot. You can't always predict things like a sweet moment between the bride and her dad (top) or a child trying to peek under a woman's dress (bottom).

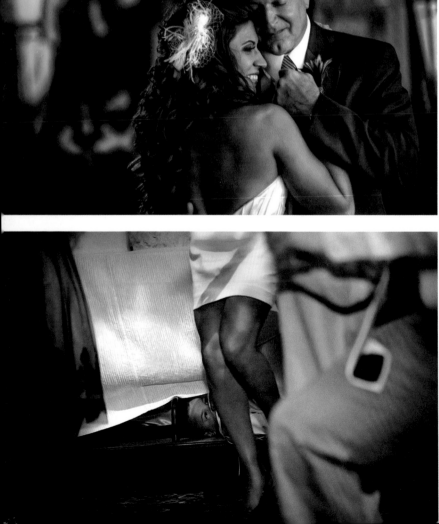

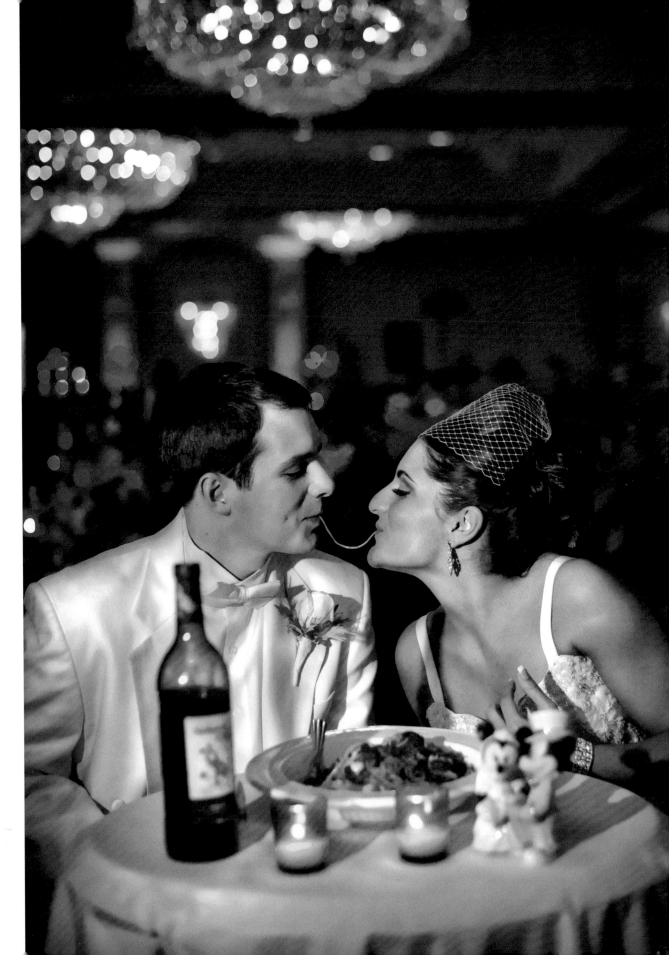

56. A Portrait Break at the Reception

A Cold, Cold Night

This image was taken at Park Country Club in Williamsville, NY, on January 2, 2010. It happened to be one of the coldest weddings I've ever photographed—it was just 10–15°F that night.

A Moment Away

While the reception is going on, I always like to step outside and take a few shots. It's nice to get away from the loud music and grab your camera and tripod to take some night shots. It helps to clear your mind and get a breath of fresh air. It also gives you a chance to see if you can get one last amazing shot to end the day.

Lighting

At this wedding, I stepped outside and immediately noticed the building giving off a beautiful glow. The main light on the bride, above her to camera right, was from a fixture mounted above a side entrance door. All I had to do was move my camera past the brick wall (seen at the very edge of the frame on the right) to cover the light so it wouldn't be shown in the frame.

Grab the Bride

Once I had figured out my angle for the shot I went and got the bride. I told her the shot would only last a couple minutes, so she put her UGG boots on and I told her where to stand and how to pose. (The shot was taken around

11PM, so the fact that she'd already enjoyed a few cocktails might have played a role in helping me convince her to come out in the cold while wearing a wedding gown.)

Exposure and Postproduction

The shot was created in 30 seconds. I shot it using the kit lens (still early in my career and I couldn't afford a FX wide-angle yet!). However, I was shooting a D3, which allowed me to shoot this at 6400 ISO with the white balance set to tungsten. Minor color adjustments were used, but that's it. I wanted to leave this image nearly untouched, so I've left the noise from the high ISO in the shot visible, to prove that no postproduction work was done.

The image eventually made it into a *Rangefinder* magazine article about my work.

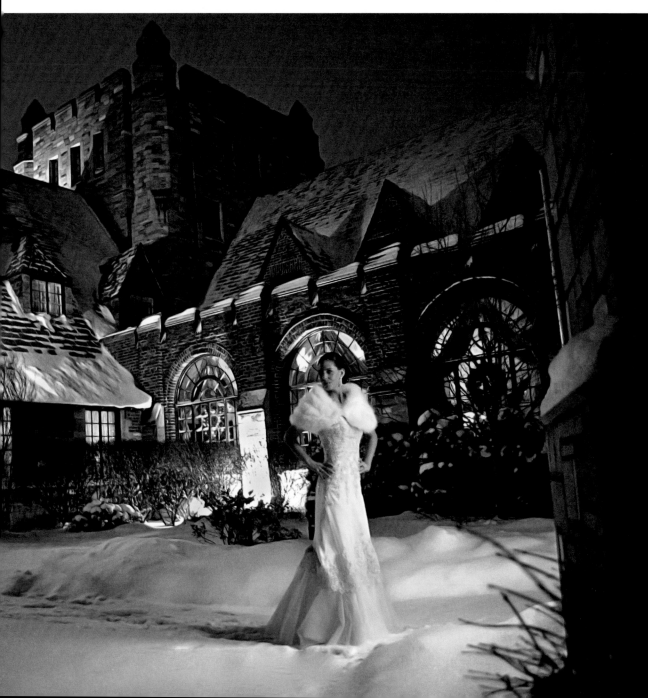

57. Ending the Night

A Final Shot

Once I'm confident that I have enough reception coverage, I like to take the couple outside for one last photo shoot. This is a great way to end the night and say our goodbyes.

The late-day images will look completely different from those created during the rest of the day, so I usually step away from the party for a few minutes to see what nature or the surrounding buildings have to offer. I also like to take a couple test shots so that I know what lighting I need (if any at all), and whether I'll need a tripod and my assistant to help. Reception halls usually offer unique lighting. If not, check out other areas—inside and out. If you don't have another option, how about using the night sky?

Short and Sweet

You don't want to take your clients away from their guests for a long time. Get creative, but make it short and sweet; this shoot should last five to ten minutes at the most.

The image to the left was shot from about 200 feet away. An off-camera flash was positioned behind them. There was no cellular service, so we had to use hand signals to get the right pose and flash setting. Even so, after a few quick tests we had it.

LEFT—I used a 200mm lens to pull the waterfall into the right perspective. See the Yosemite image in section 37 for another example of this.

Check Your Gear

My lighting tools are small (see the sidebar in section 30) and all fit into one bag that my assistant carries. If you shoot solo, you can easily carry everything you need over your shoulder. Just don't forget and leave it behind like I have sometimes done! Check to make sure you have everything with you before you head home.

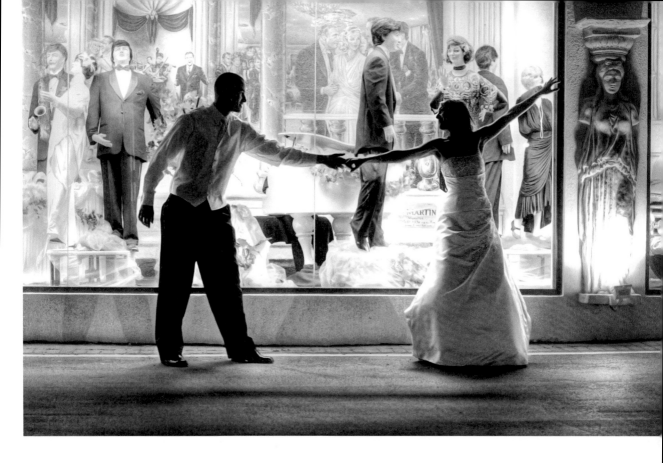

58. When Is It Time to Go?

A Controversial Subject

It's always been a controversial subject: When is it okay for the photographer to leave the wedding? Some say after the dances (couple's first dance, mother/son dance, father/daughter dance). Others stay all the way until the end of the night. Still others leave at the end of the eighth or tenth hour, based on the amount of time they have been contracted to work.

One Last Shot

The photo below was made at the end of the night. The videographer and I took the couple into the lobby of the reception site, a grand old theater, and grabbed a candelabra from the head table as a prop. The bride let her hair down so that the shot had contrast from the photos we took earlier in the day.

Danielle held the Lowel light high to camera right. I engaged the spotlight feature on this light, something I rarely use, to make it look like the light was coming from the candelabra.

When we were done with this dramatic portrait of the bride, we said our good-byes and called it a day.

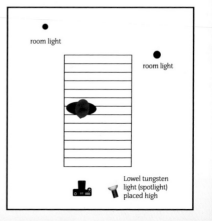

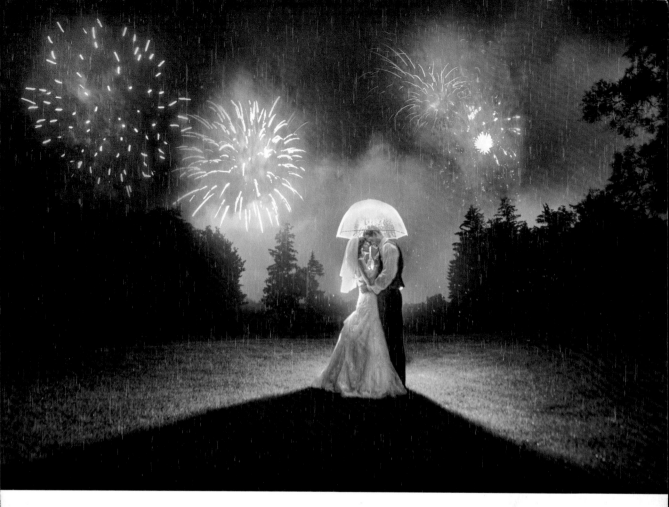

Our Practice

At the start of our wedding photography career, we always stayed at weddings until the end of the night. When the DJ packed up, we packed up. Eventually, however, we learned that brides really don't need (or want) a thousand shots of Uncle Bill busting the same move on the dance floor.

Now, we play it by ear. We definitely don't want to leave when the party is getting going. However, when we reach the point where we're getting the same things over and over, we know it's time to call it a day.

If a good opportunity presents itself, we might still do one last photo shoot to end the night, then say our good-byes. Our wedding days typically last ten to twelve hours—so what's an extra hour if you're going to get some great shots?

How You Bill

I should also note that we never charge by the hour, because I think the last thing a bride and groom need to worry about on their wedding day is the time left on their photographer's clock. They should never glance over at their photographer and catch them looking at their watch. If I were the groom, I wouldn't want to see that. It's no way to make your client feel special or valuable.

59. Post-Bridal

More Opportunities

Some people call this session a "trash the dress" shoot, but I prefer to call it a post-bridal session (see sidebar). This is a shoot, scheduled for after the wedding day, that gives us a chance to work at a location we couldn't get to on the wedding day. The options are limitless.

It's All Up to You

For photographers, the best part about this type of shoot is that we not only help to decide on the location, but we also get to choose the time of day the shoot is scheduled. We get to put the bride in the best lighting possible—and if the weather man calls for rain, we can reschedule.

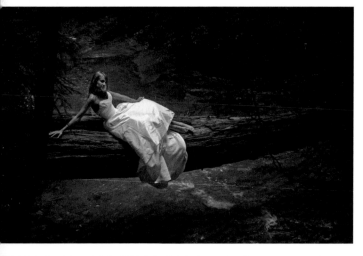

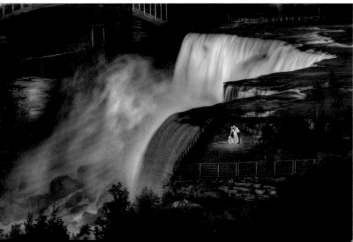

Or better yet, we can shoot in the rain and take advantage of the elements.

The bride shown above wanted her shoot at a waterfall. I left it up to her how she wanted to treat her dress. I simply told her that if she wanted to go into the water, I'd follow her. She

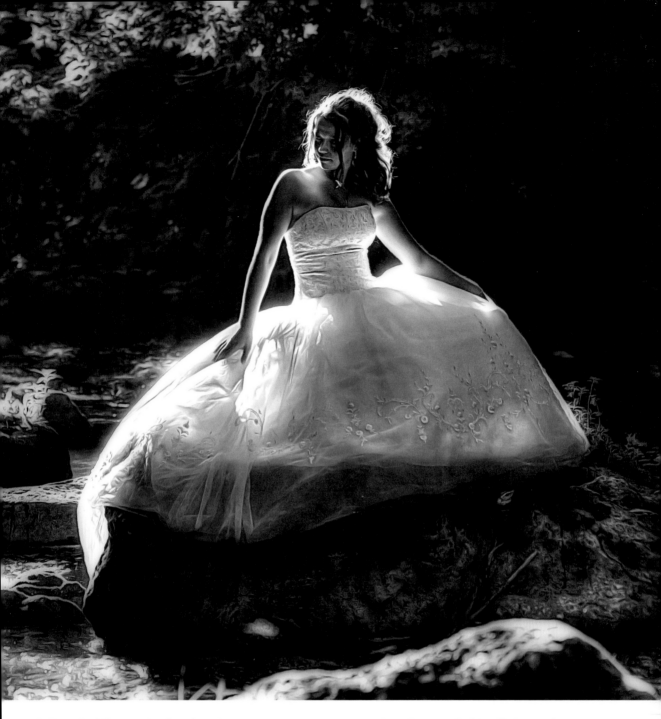

ended up deciding to do that, but the water was clean so the dress got wet but not trashed.

The shot above was created before she ended up in the water. I helped her onto the rock and sat her down. The setting sun peeked through the dense woods on the shore, backlighting her with a nice glow. It was splashing light on the rocks in the stream, so no bounce light or fill flash was necessary.

Choose Your Words

I've never liked the phrase "trash the dress," so I avoid it. Brides (and moms of brides) seem to get turned off by the words. Why on earth would you want to trash a dress made for the happiest day of your life?

Conclusion

Throughout this book, I've tried to show you how I approach wedding photography. This is what works for me, and these techniques might work for you, too.

Learn from others, but don't be afraid to think for yourself, too. You shouldn't regard any technique as a "rule" that can *never* be broken. Once you've mastered the basics, expand your skills and build your personal style by experimenting and playing. Challenge yourself to achieve greater variety, better lighting, more flattering poses, and ever-more creative results for your couples.

Get inspired and informed by how pros you admire approach their work, then look for how those techniques (or "rules") might be adapted to enhance your style. And don't just follow the work of other *wedding* photographers; in our genre, we can readily implement ideas from portrait, landscape, fashion, and architectural photographers, too.

"Learn from others, but don't be afraid to think for yourself."

I hope this book has given you ideas to improve your skills and to be more creative in your own approach to wedding photography!

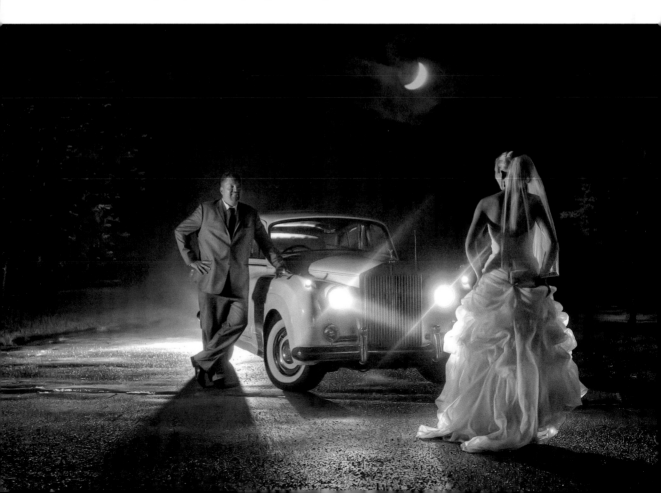

Index

500 Poses for Photographing Couples

Michelle Perkins showcases an array of poses that will give you the creative boost you need to create an evocative, meaningful portrait. *$34.95 list, 8.5x11, 128p, 500 color images, order no. 1943.*

500 Poses for Photographing Brides

Michelle Perkins showcases an array of head-and-shoulders, three-quarter, full-length, and seated and standing poses. *$34.95 list, 8.5x11, 128p, 500 color images, index, order no. 1909.*

500 Poses for Photographing Groups

Michelle Perkins provides an impressive collection of images that will inspire you to design polished, professional portraits. *$34.95 list, 8.5x11, 128p, 500 color images, order no. 1980.*

Step-by-Step Lighting for Outdoor Portrait Photography

Jeff Smith brings his no-nonsense approach to outdoor lighting, showing how to produce great portraits all day long. *$27.95 list, 7.5x10, 128p, 275 color images, order no. 2009.*

Photograph the Face

Acclaimed photographer and photo-educator Jeff Smith cuts to the core of great portraits: making the subject's face look its very best. *$27.95 list, 7.5x10, 128p, 275 color images, order no. 2019.*

The Right Light

Working with couples, families, and kids, Krista Smith shows how natural light can bring out the best in every subject—and produce highly marketable images. *$27.95 list, 7.5x10, 128p, 250 color images, order no. 2018.*

One Wedding

Brett Florens takes you, hour by hour, through the photography process for one entire wedding—from the engagement portraits, to the reception, and beyond! *$27.95 list, 7.5x10, 128p, 375 color images, order no. 2015.*

Flash and Ambient Lighting

FOR DIGITAL WEDDING PHOTOGRAPHY

Mark Chen shows you how to master the use of flash and ambient lighting for outstanding wedding images. *$34.95 list, 8.5x11, 128p, 200 color photos and diagrams, index, order no. 1942.*

We're Engaged!

Acclaimed photographers and photo instructors Bob and Dawn Davis reveal their secrets for creating vibrant and joyful portraits of the happy couple. *$27.95 list, 7.5x10, 128p, 180 color images, order no. 2024.*

The Beautiful Wedding

Tracy Dorr guides you through the process of photographing the authentic moments and emotions that make every wedding beautiful. *$27.95 list, 7.5x10, 128p, 180 color images, order no. 2020.*